MARY CASSATT

PAINTINGS AND PRINTS

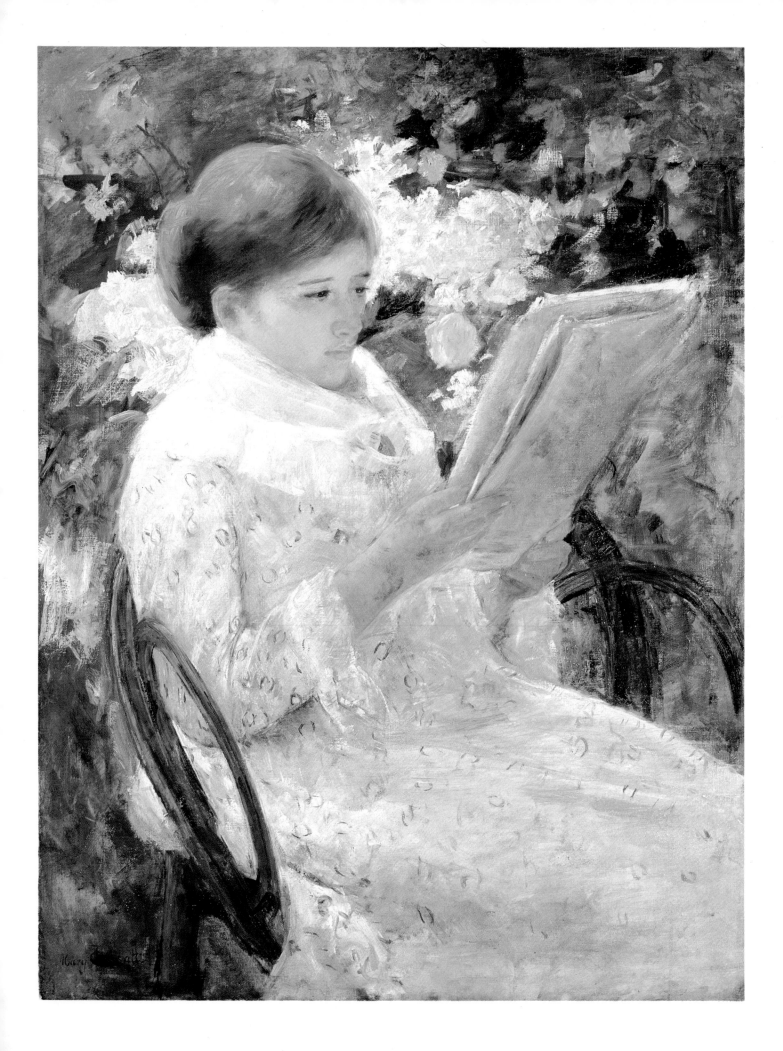

MARY CASSATT

PAINTINGS AND PRINTS

BY

FRANK GETLEIN

ABBEVILLE PRESS · PUBLISHERS · NEW YORK

ON THE COVER:

Woman Bathing (1891)
Commentary on page 86

FACING THE TITLE PAGE:

Lydia Reading in a Garden (1880)
Commentary on page 32

Library of Congress Catalog Card Number: 80-66523

ISBN O-89659-155-7

CONTENTS

INTRODUCTION

O NE OF THE MAJOR DEVELOPMENTS in American society over the last two decades has been the emergence of more and more women who demand and attain economic and political parity with men.

Mary Cassatt would have approved enthusiastically of the women's movement. She herself became liberated at a time when many people believed, or pretended to believe, that a liberated woman was the same as a loose woman. Cassatt left her home in well-off Philadelphia and went to Paris, seen by many Americans as the capital of sin whatever its position might be in art. She proclaimed herself an independent, in art as in life. She never married, lived chiefly for her work, and from an early stage supported herself as a professional painter by selling the paintings she created.

Mary Cassatt believed deeply in what is today called women's liberation. She contributed to the movement for women's suffrage whenever she was asked, and was particularly proud, and went to considerable trouble, to paint a mural for the Women's Building at the Chicago Exposition celebrating the four-hundredth anniversary of the discovery of America. (Unfortunately, that work, the largest she ever executed, disappeared in the confusion of closing down the Exposition. It has never been seen since and must reasonably be assumed to have been destroyed.)

Mary Cassatt's views on women's liberation and her own thoroughgoing practice of it are intrinsic to an understanding of her work, unlike, for example, Picasso's Communism, which meant absolutely nothing to his art, or the Fascism professed by some of the Italian Futurists, which had only the most superficial connection to their work. But Cassatt's feminism in thought and politics corresponds precisely to the feminism in her work. She painted men, occasionally, mostly members of her family. She did no still lifes and no landscapes except as incidental to her figure painting. The figures she usually painted were women and children, even infants in their mother's arms.

Some contemporary feminist theory precludes having babies and raising

children for the truly liberated woman. That view was certainly not widely practiced during Mary Cassatt's lifetime. She lived from 1844 to 1926, and in those eight decades, whether in Pittsburgh, her birthplace; Philadelphia, where she came as a child; or in Paris, where she spent her working life, Cassatt lived in societies in which babies and child-care were essential parts of "feminism." She was able to penetrate those areas of women's lives without actually participating in them, and did so as perhaps no painter has before or since.

It is necessary only to think of her contemporary countrymen who supposedly "celebrated" womanhood and maternity in their art to appreciate her achievement. There is never a false step in her portrayal of mothers and children, no easy idealization of the notion of Woman or Maternity like that found in the work of painters like Abbott Thayer, who clearly had little idea of woman or maternity but a very good idea of what sentimental art buyers would be happy to buy.

Mary Cassatt painted what she saw in front of her, and the evanescent light in which she saw it, as was customary among her fellow-impressionists. She detested the term "impressionist," and never used it, to the end of her days referring to her colleagues and herself as "independents." Nevertheless it was her fidelity to the impressionist approach and her sensitivity that enabled her to paint psychological states as well as the state of the light, that allowed her to paint mothers and children in so uniquely penetrating a way.

With women she was, of course, at home, working from the inside. At that time the world of women by themselves or with other women was relatively hidden, but it is revealed to us in Mary Cassatt's best pictures: an old woman pours tea; a young one leans forward in her box at the opera, enjoying everything she sees and hears; two women sit at tea; an older woman reads her paper; a younger one sews or works the tapestry frame; two women sit in a garden. These women of all ages are beings in themselves. They do not exist, as so many women in art and literature do, for the sake of the male artist, or the male hero, or the male buyer.

So Cassatt is set apart not only from Abbott Thayer but also from such great painters of mothers and children as Raphael. Raphael was a greater artist than Mary Cassatt, and for that matter greater than all of the impressionists, but in one important respect the Victorian American woman accomplished things the Renaissance Italian man did not.

Mary Stevenson Cassatt was born on May 22, 1844, in Allegheny City, now a part of Pittsburgh. She was the fourth surviving child of Mr. and Mrs. Robert Simpson Cassatt. Her father made money in real estate and stock brokerage but

refused to devote himself wholeheartedly to either. He was mayor of Allegheny City for a while and held other posts of municipal trust. When Mary was five, the family moved to Philadelphia, which all her life Mary regarded as her American base, presumably because her brothers Aleck and Gardner lived there. Two years later, the Cassatts moved to Paris.

We do not know exactly when Mary Cassatt determined that she wanted to be an artist, but it was very early. She saw Paris at the age of seven and it was love at first sight. Two years later the family moved on to Heidelberg, then to Darmstadt, to further the engineering studies of brother Aleck. Another brother, Robert, died in Darmstadt in 1855, and the family returned to Philadelphia, stopping in Paris to see the Universal Exposition, which included an international art exhibition dominated by Ingres and Delacroix. Outside the official, imperial precincts, Gustave Courbet exhibited his own pictures in his Pavilion of Realism. All of this must have made an impression on the eleven-year-old Mary.

Six years later, in the first year of the Civil War, she enrolled in the Pennsylvania Academy of Fine Arts, the country's most venerable and most revered art school. She stayed there four years, moving through the traditional curriculum of drawing from casts of antique sculpture, drawing from life, and copying paintings. Here she decided that copying Old Masters and studying their works was the best road to mastering art. In 1866, she moved to Paris, studied briefly in a studio conducted by an established artist, Charles Chaplin (no relation), and spent most of the next four years studying on her own in the museums, copying Old Masters, and making sketching trips in the country.

Just as the outbreak of the Franco-Prussian War sent Monet and Pissarro to London, where they would encounter the nature paintings of Constable and Turner, it sent Mary Cassatt back to Philadelphia. When the war ended, she returned to Europe, settling in Parma to study Correggio and Parmagianino. While in Parma she also attended the Academy to study engraving. In 1872 she had a painting accepted in the Paris Salon and the following year settled permanently in Paris, after study trips to Spain and Belgium. She met Louisine Waldron Elder whom she persuaded to buy a Degas pastel. This was the first impressionist picture to come to America, and the first acquisition of what became the H.O. Havemeyer Collection, one of the great foundation blocks of the Metropolitan Museum of Art Collections.

For Mary Cassatt, however, the example of Degas, the precepts of Degas, and the friendship of Degas were more important than anything. When she met

Degas and became his friend, she sealed her destiny as an artist. She had been accepted for five years in a row for the Paris Salon, but such was her admiration for Degas that at his invitation she abandoned the Salon, joined the independents and henceforth showed her work with them—when they could agree on an exhibition.

Degas had a greater influence on Cassatt's work than Correggio, Parmagianino, or anyone else. In Degas's paintings and drawings, Mary Cassatt immediately recognized what she herself had been working toward. In turn, the older artist saw in her a possible disciple, a highly talented junior, an exotic American and yet, at the same time, a fellow citizen of the same social milieu. Degas came from a family of bankers, and hence from the same general occupational sphere inhabited by Mary Cassatt's real-estate speculating, stock-brokering father, her corporately and socially successful brothers. (Her brother Aleck had married Lois Buchanan, niece of President Buchanan, while Mary was in Paris before the Franco-Prussian War.) The similarity of background, against which, to some degree, both rebelled without ever repudiating it, gave them common ground neither ever found with more bohemian members of the independents. Both believed in the art of the museums, and were mistrustful of casting themselves adrift on the moment. In many ways, they were made for each other.

Artistically, that is, socially, and intellectually. There is no evidence that any sort of romantic liaison ever existed. Degas and Cassatt were both Independents in more than their group artistic affiliation. Both were a little quirky, quick to respond to real or fancied offense, sensitive to what was due them and what they need not accept, resentful of being put upon by anyone. In addition, both were tied up with their respective families: Degas underwent severe financial strain to pay off the debts incurred by the failure of the family bank in which he had no interest and certainly no managerial concern. And Mary's father and mother and sister Lydia joined her in Paris and lived with her most of their lives. Thus, the sheer mechanics of any clandestine relationship would have been formidable, had there been the desire. We can probably assume that there was not.

For some decades Mary Cassatt pursued her career successfully on both sides of the Atlantic at once. However, she suffered the loss, one by one, of family members who were dear to her, the loss of Degas in the middle of World War I, the dimming, eventual loss of her own eyesight, and the surrender of her lifetime of productive working habits. Toward the end, she even broke with her oldest friend, Louisine Havemeyer. She died in 1926.

MARY CASSATT

PAINTINGS AND PRINTS

The Bacchante

1872

LIKE ALL GREAT ARTISTS, Mary Cassatt was self-educated, and she took her art education upon herself as soon as she could. Shocked by his daughter's announcement that she wanted to be an artist, her Philadelphia banker father did what seemed to be the obvious, sensible thing. He enrolled her in the Pennsylvania Academy. She dutifully attended and worked from plaster casts and made good copies of bad paintings; but she knew better. She took herself to Paris, ostensibly to visit family friends, actually to work. After three years she came home to get out of the way of the Franco-Prussian War and almost at once crossed the ocean again, this time to Parma. Besides the ham, the cheese, and the violets, the city has Correggio, who decorated the dome of the Duomo and other parts of it as well. Cassatt avidly studied the children who so largely populate his paintings. If Degas, not yet even a name to her, was to be her great master and teacher, Correggio was her first.

The bacchante was a popular academic subject in 1872, offering as it did the cherished academic opportunity to display young girls with few, or no, clothes on, while invoking the semireligious sanction of antiquity. Cassatt, painting in Parma under the clear eye of Correggio, did not succumb to the temptation of easy eroticism. Her bacchante is, immediately, a real person. The vine leaves in her hair are underplayed, the cymbals are more than props, they are closely observed in their well-used, slightly battered state. The dancer's fixed intensity of expression reveals well enough the transport sought by the wine-god's devotees. But Cassatt herself emerges in the powerful instinct for the bones beneath the flesh and for the flesh in light and shade.

Oil, 23⅞ × 19⅞"

Gift of John F. Lewis
Pennsylvania Academy of the Fine Arts, Philadelphia, Pennsylvania

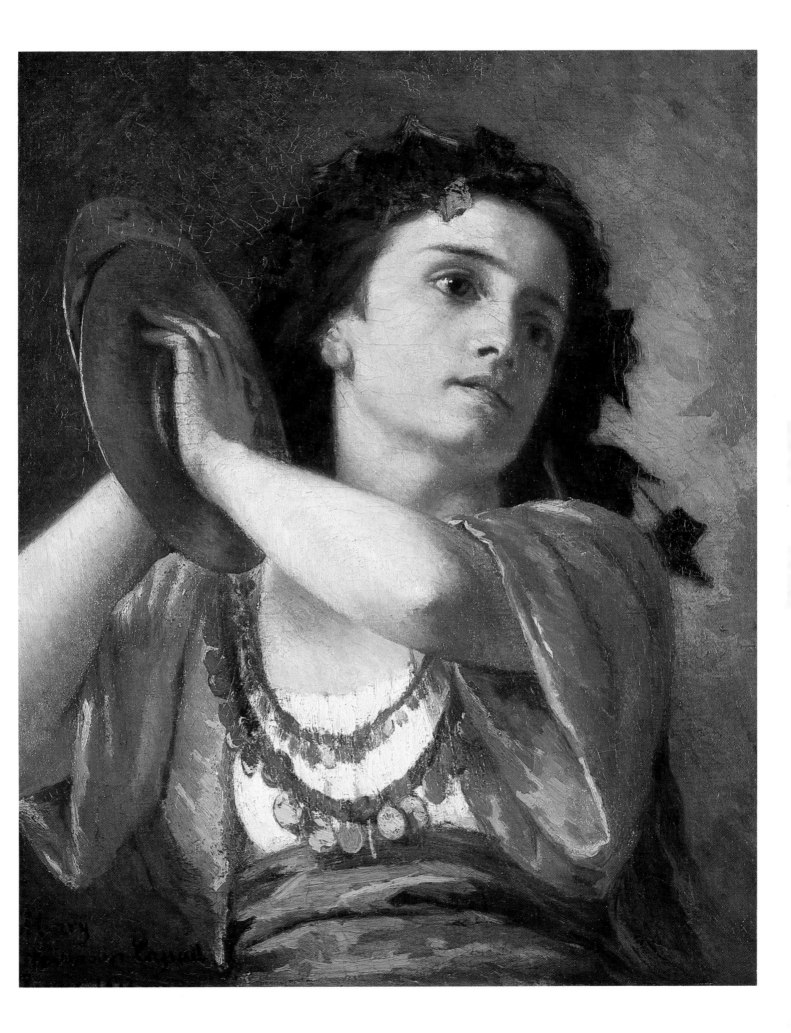

The Young Bride

c. 1875

CASSATT HAD BEEN IMPRESSED by Correggio in Parma, by Rubens in Spain. Meanwhile, the Paris Salon accepted her paintings three years in a row, and she made Paris her permanent home. It was there that she first saw the work of Edgar Degas, then still relatively unknown, but already a dominant figure in the group of painters who would become the Impressionists. Degas and Cassatt met each other through their works. Cassatt saw paintings by Degas in a gallery window and said later she could never describe the effect they had on her, of opening up a new world of art that had never occurred to her. As for Degas, he saw a painting of a red-haired girl by Cassatt in the Salon and said, "There is someone who feels as I do."

In the time between their "sighting" each other and their first meeting, Cassatt firmly established herself in Paris as an independent woman and an independent painter. She set up and maintained a household, kept a horse and rode it in the Bois de Boulogne, haunted the Louvre, took classes briefly, and painted all day every day.

The Young Bride is an early, modestly glowing example of Cassatt's life work: painting the feminine side of marriage, at the same time as she kept herself away from marriage. The subject was a maid of the artist, Martha Gansloser, to whom Cassatt gave the painting as a wedding present.

Oil, 34½ × 27½"

Gift of Max Kade Foundation
Montclair Art Museum, Montclair, New Jersey

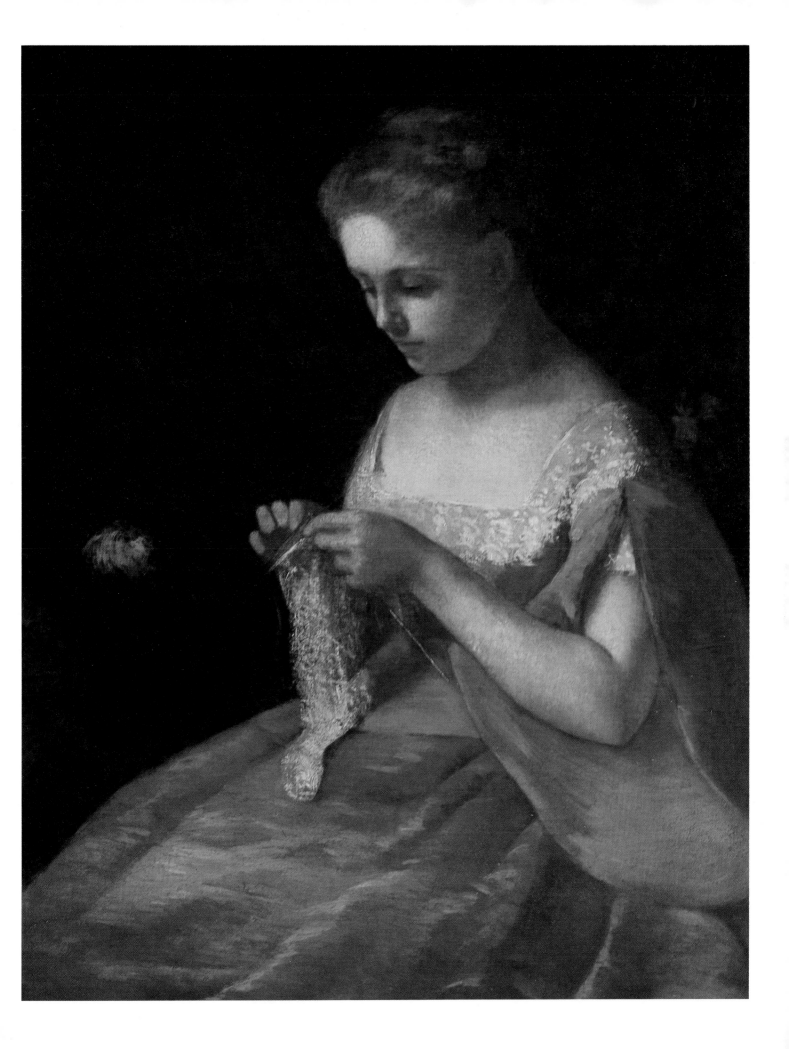

Little Girl in a Blue Armchair

1878

WHAT A PICTURE! If anyone had had doubts about Mary Cassatt's abilities, this alone should have settled them. For the Paris Exposition of 1878, it did no such thing. The painting was rejected, as Mary Cassatt said later, "by a jury of three people of which one was a pharmacist!" She was furious. The experience made her loyalty to the Independents more firm than ever and years later caused her to refuse two American prizes in a single year, explaining patiently that she rejected the whole system of juries and prizes.

Her fury was the greater because Degas had not only thoroughly approved the picture but had worked on it himself. Specifically he advised her on the background, and it is there, with the floor and the light from the farther window, that he probably made his own contribution to a remarkable painting.

Influenced by Degas and by the Japanese prints then newly popular in Paris, Cassatt has close-cropped all four sides of the scene. We cannot see a single one of the chairs and settee entirely, nor the windows, nor the draperies. Only the little girl and the dog—one of the artist's Belgian griffons—are seen whole. The girl sprawls in the chair, at loose ends physically and psychologically. The dog dozes.

The tilt of the picture plane presents the little girl to the viewer as does the whole train of great blue furniture, coming right across the picture to culminate in the chair she lies in.

Oil, 35 × 51"

Collection of Mr. and Mrs. Paul Mellon
The National Gallery of Art, Washington, D. C.

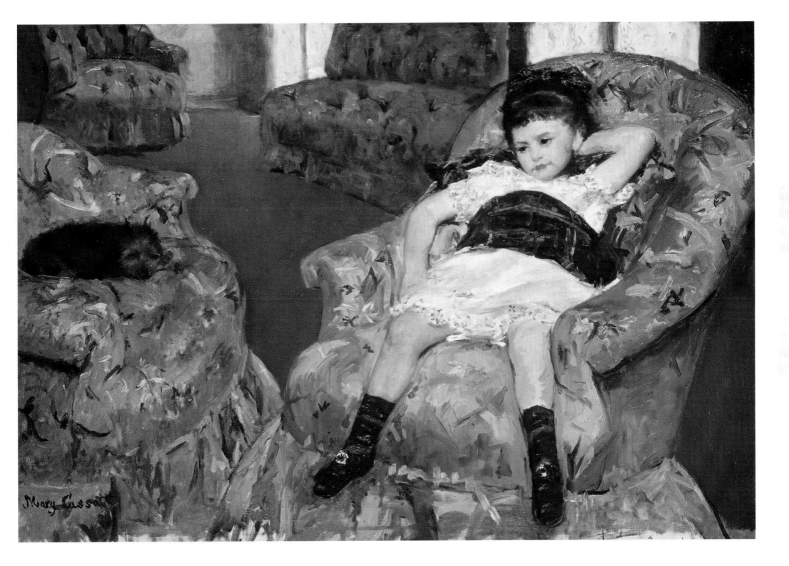

Portrait of Lydia Cassatt (No. 1)

1878

As THE FULL TITLE IMPLIES, there is a second version of this painting, in the Norton Simon Collection in Fullerton, California. The Norton Simon picture, of about the same size, includes as background an iron balcony grill framed by a window, with greenery beyond, in the area here occupied only by vibrantly colored space. The other details are much the same, although Lydia seems to be even more slouched and the newspaper more in shadow than in reflecting light.

Before it went to Omaha, this painting hung in the Paris apartment of Dikran Kelekian for more than forty years. Kelekian, a distinguished art collector, always referred to it as "one of her earliest paintings," and indeed, although it is No. 51 in Adelyn Breeskin's *Catalogue Raisonné* of Cassatt's work, it is nevertheless one of the very first paintings in which Mary Cassatt reveals herself as Mary Cassatt.

The previous year she had painted a portrait of the young Mary Ellison embroidering that could have been painted by Gilbert Stuart: this is no denigration of Gilbert Stuart, only a reminder that Cassatt was very different. A few years earlier still, she was painting copies of Frans Hals, Spanish local-color paintings, a variety of things and styles all of which showed talent, none of which showed Cassatt.

Portrait of Lydia Cassatt shows Cassatt. The beloved sister is seen absorbed in what she is doing, not in the least aware that she is being painted. There is a total informality about the painting. Lydia, slouched against the green chair, reveals perhaps a touch of nearsightedness. The informality goes beyond her morning dress: the boudoir cap, ruffled fichu, slack white dress with blue dots. It's in the pose itself and most of all in the attitude of the painter. This is the true, the honest, the domestic, the familial Mary Cassatt.

The green upholstered chair is worth a close look. The painting conveys the comfortable upholstery, but it also conveys painting. Those clear brushstrokes, with their lively rhythm and varying green tones punctuated by red, are among the first examples of a style destined to endure through many varieties of painting for nearly a century.

Oil, 31 × 23¼"

Joslyn Art Museum, Omaha, Nebraska

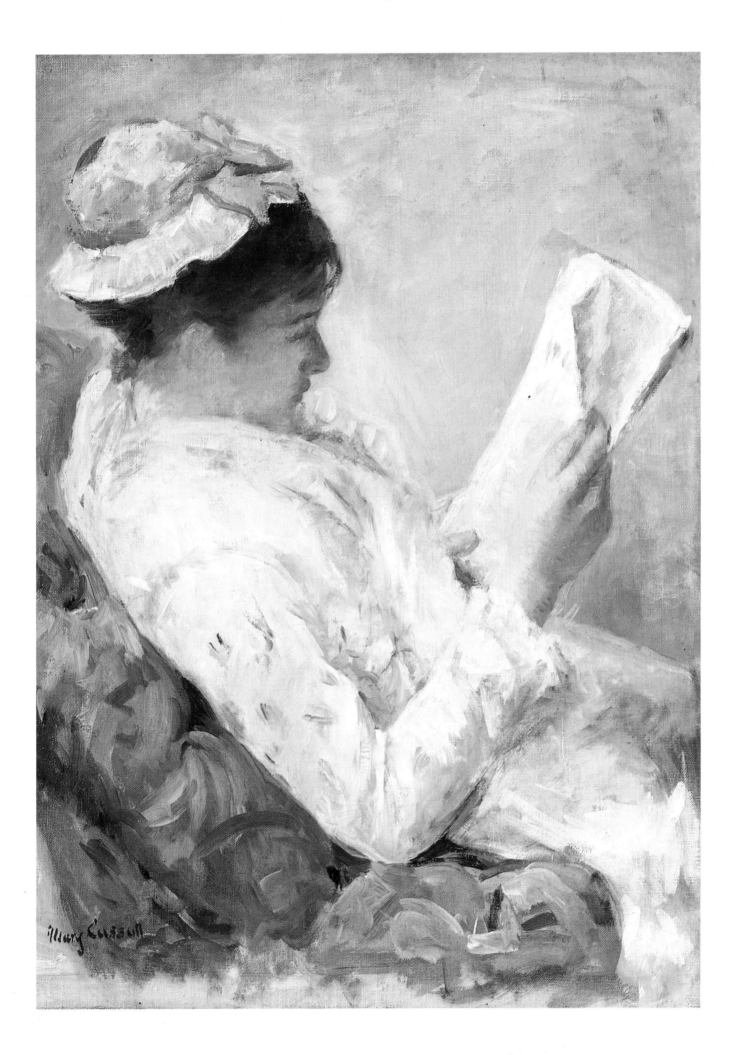

The Cup of Tea

1879

THE CHALLENGE TO A PAINTER in Mary Cassatt's situation—and her considerable achievement—is to keep painting the same people in the same places and have every painting come out fresh and new. She achieved that through habitual, minute observation. If, as scientists and theologians assure us, there is a universe in a drop of water, there is infinity in the taking of a cup of tea, and Mary Cassatt has explored the degrees of that infinity.

Here Lydia, taking her cup of tea, is framed between the solidity of the broadly striped, comfortable chair and the evanescence of the hyacinths, both of which contrast in color to her exquisite shell-pink, lace-trimmed dress and bonnet to match. Lydia herself partakes of both the solidity and the evanescence. The chair is turned away from the wicker flower stand holding the hyacinths, so that the "frame," which is formed by the stand and the right arm of the chair, opens toward the unseen rest of the room.

A quiet special strength of Mary Cassatt was her sometimes uncanny ability to differentiate in paint between a fabric-draped human being, a fabric-covered piece of furniture, and the flowers which might well be imitated in both fabrics. She does that here almost breathtakingly in the juxtaposition of Lydia's hat and head with the hyacinths, her body with the chair.

Oil, 36⅜ × 25¼"

The Metropolitan Museum of Art, New York City

20

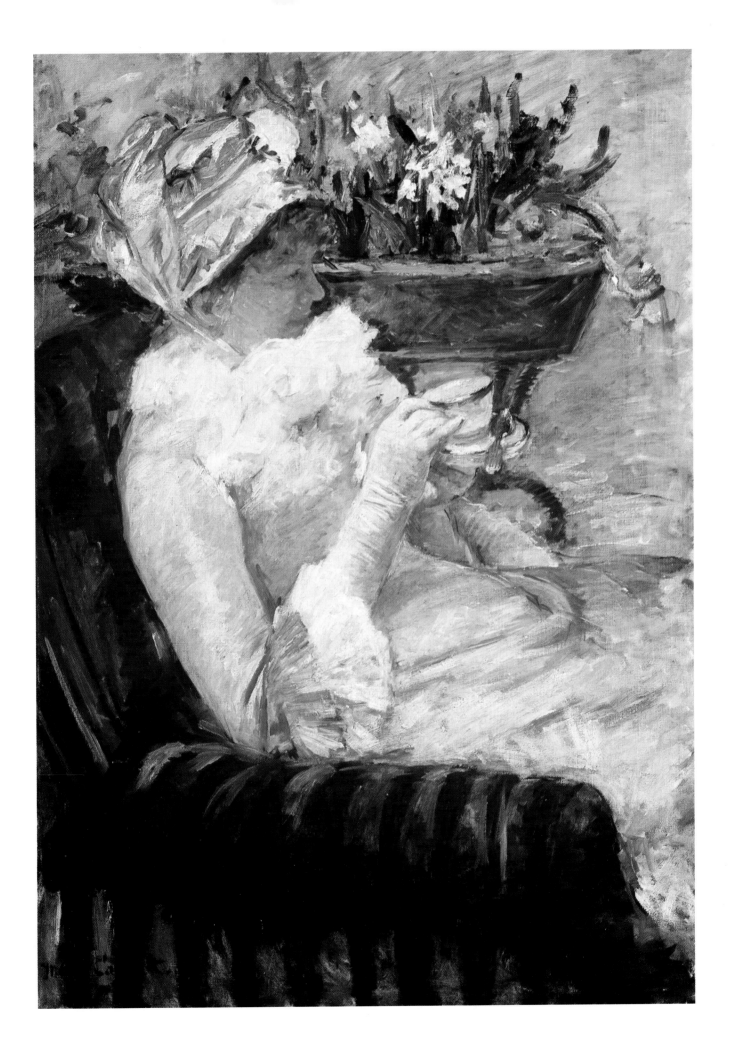

Lydia Leaning on Her Arms, Seated in a Loge

c. 1879

THIS IS ONE OF A PAIR of particularly happy pictures of Lydia in a loge, a place which, on the record of her sister Mary Cassatt's painting, was a favorite location for her, second only to the Cassatt garden in Paris. In contrast to the companion picture, an oil in which she sits back during an intermission, taking in the fashionable crowd of which she is herself part, here Lydia leans forward, watching the performance, her back reflected in the mirror of the loge wall and a lighted chandelier also in the background.

A close-in view of its subject, the picture is full of ovals: the top of Lydia's coiffure, the bottom of her chin, the round of her shoulders, the décolletage of her yellow gown, the cut of her sleeves, behind her the curve of the banquette she occupies, above the softly rounded bottom of the chandelier, plus the reflections of her hair and shoulders in the glass.

Within this round of rounds, the color by contrast comes on in flurries of short, sharp strokes. One color is overlaid on another, with little attempt to synthesize them by rubbing them together in the classic pastel manner, and the synthesis is left to the eye, where indeed it takes place.

The overall effect is of the shimmer of light over variously colored surfaces with the shimmer itself finally being more important than the colors it decorates, and all within the ovals.

Out of these technical niceties emerges the image of a young woman in rapt attention to what is going on before her on the stage.

Pastel, 21⅝ × 17¾"

The Nelson Gallery-Atkins Museum, Kansas City, Missouri

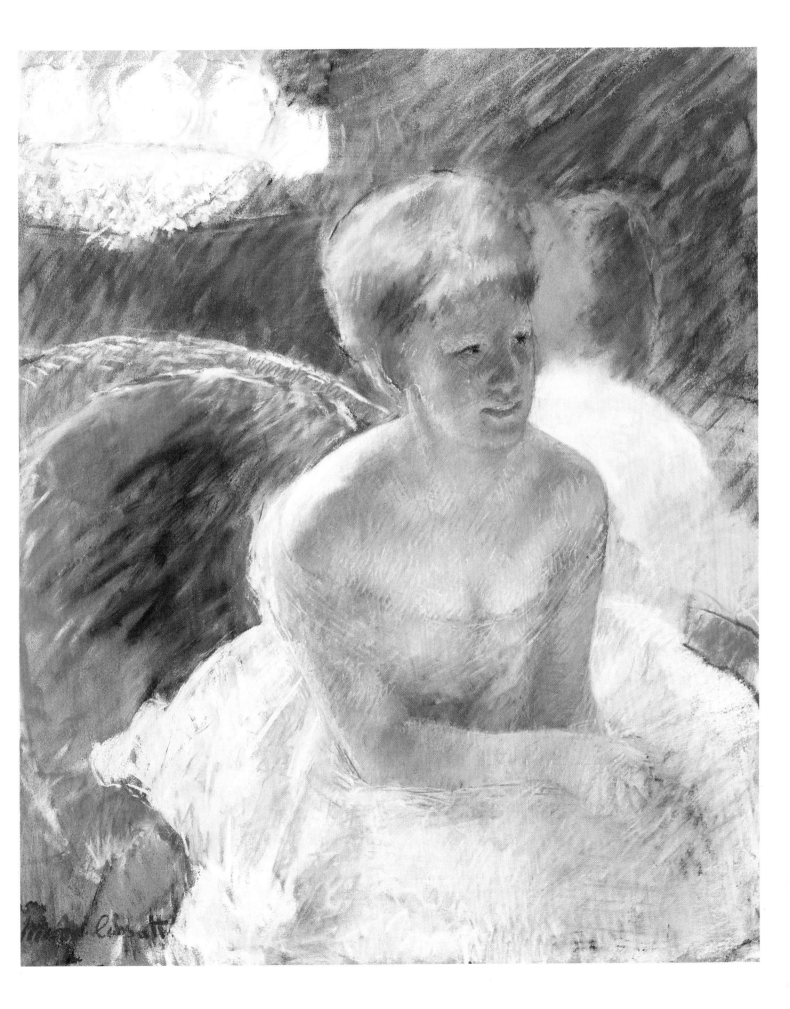

Woman and Child Driving

1879

IN 1879, ALEXANDER CASSATT, Mary's successful brother, who was president of a railroad, set up a trust fund for his parents, who were now living in Paris with Mary, her sister Lydia, and assorted American relatives. The most immediate effect of the trust was the purchase of the pony and pony cart pictured here with Lydia at the reins. A niece of Degas's is holding on for safety, and a noncommittal groom is riding backwards (as grooms did when their mistresses took the reins).

Lydia is new at the game, and totally attentive as she holds both reins and whip. The Degas niece, Odilie Fèvre, seems none too certain of her own safety. The groom, besides being noncommittal, stares off in the opposite direction from the others. As a result, there is no eye contact between any of the three people—which is very unusual in a Cassatt painting. Each one is alone with his or her own opinion of what's going on, and that may well have been Mary Cassatt's intent, painting, as always, what she perceived psychologically as well as visually.

It's a handsome composition, a close-up of the kind Cassatt and Degas had found in old Japanese prints and new Parisian photographs. We see only the rump of the pony, the top of the wheel, and the top half of the groom. But that is enough, and the little avenue of trees gives an opening out of the compressed space of the painting.

Oil, 35¼ × 51½"

The W. P. Wilstach Collection
Philadelphia Museum of Art, Philadelphia, Pennsylvania

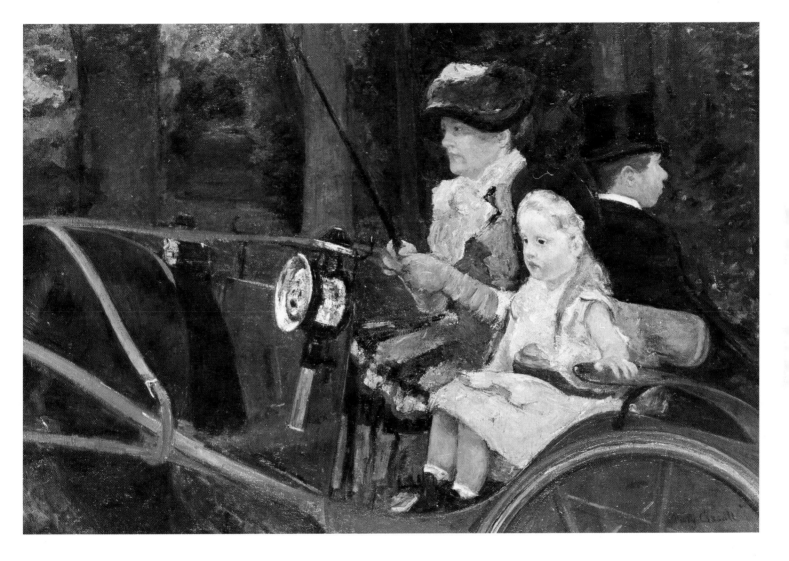

At the Opera

1880

LIKE HER MENTOR, Degas, Cassatt enjoyed painting members of the audience at the opera, but her love for opera began long before she met him. She attended musical performances of all kinds in Philadelphia, and the opera at Parma was a special joy. When she came to paint scenes at the Paris Opera, she was essentially doing what she did at home, in her various country houses, in gardens and parks: painting a familiar environment in which she was comfortable and happy. Often enough, she was even painting the same people, especially her sister Lydia, subject of several sparkling opera pictures, and assorted visiting American relatives.

Here, however, the woman in black is a stranger, an afternoon opera-goer intent, through her glasses, on something or someone decidedly not on the stage, just as, a few boxes away in the same circle, a gentleman opera-goer, through *his* glasses, is intent on her. The velvet-covered rail along the loges links the two viewers, each of whom has an elbow on it to steady the glasses. There are almost no anecdotal pictures in Mary Cassatt's work and this is not really one. The interest is visual in two senses: The moment has been visually caught by the painter, and the two principals are using their own eyes before our eyes. It is an observation observed and then observed again.

The composition is based on two complementary triangles, with the dark of the lady dominating half the picture in its solidity, and the open space of the other, inverted triangle measured by the white and gold bands of the loges and their partitions. Cassatt's casual-seeming paint-handling of the gold-and-white decorations and indeed of the other audience members is notable as is the painting of the transparent gloves worn by the woman in black.

Oil, 31½ × 25½"

Hayden Collection
Museum of Fine Arts, Boston, Massachusetts

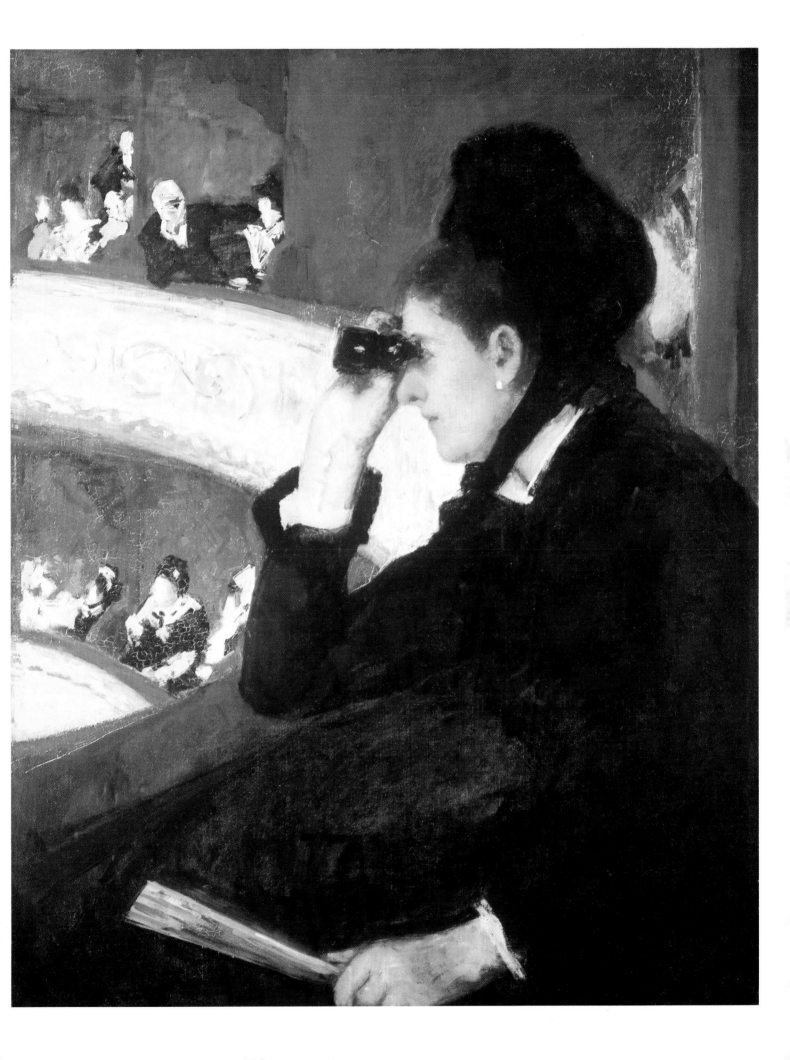

A Cup of Tea

1880

THIS IS A FASCINATING PICTURE not only as a superb Cassatt, but also as a kind of pictorial summation of the way the artist lived outside her art, the quietly elegant life of her friends and relations in Philadelphia and Paris. It is also, of course, a magnificent example of Cassatt's great gift to all of us, namely the penetration of the world of women of her time and place. This is not to say that women are or ought to be limited to taking tea at five o'clock, reading in the garden, and bathing their babies. It is simply that women of the leisure class spent a great deal of time in such activities in Mary Cassatt's day and in her circle, and more than that, that Cassatt knew and painted women and their world from the *inside*. In contrast, almost the whole history of art presents women as objects; whether they are Venus, the Virgin Mary, a classical form of beauty, or a saucy baggage, they are *they*, people out there to be looked at for their surfaces. With Mary Cassatt, almost for the first time, women become subjects, they are *we*.

Lydia, at the left, entertains. Her guest lifts her cup, obscuring half her face, but both women are quiet and at home with each other. Their plain simplicity contrasts wonderfully with all the convoluted elegance on the right side of the painting. The exquisitely painted silver tea service prepares us for the baroque and rococo twists and turns of the fireplace, the Oriental vase on the mantelpiece, and the elaborate gilt mirror frame. The bell-pull serves as boundary and transition, at once related to the plain, straight rose bars of the wallpaper and to the elegance of the right background.

Oil, 25½ × 36½"

Maria Hopkins Fund
Museum of Fine Arts, Boston, Massachusetts

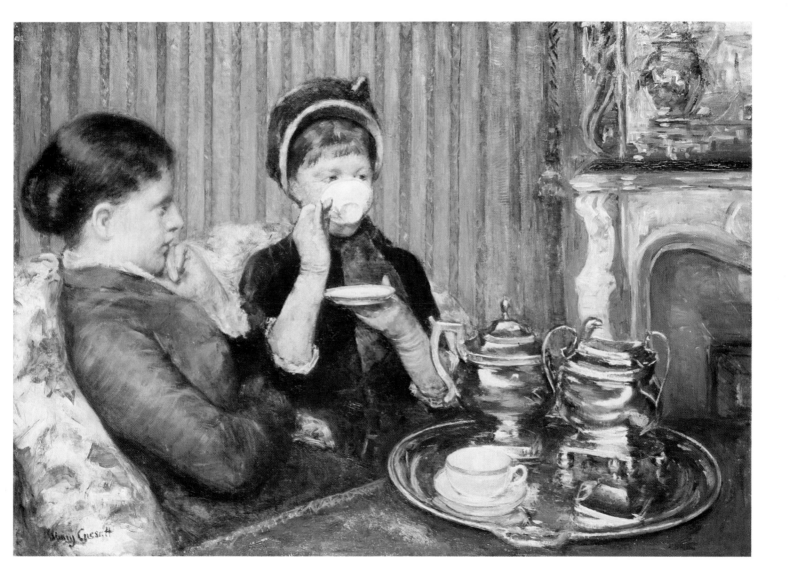

Lydia Crocheting in the Garden at Marly

1880

LYDIA WAS CLEARLY THE JOY of Mary Cassatt's life in Paris, but the joy was short-lived. Lydia Cassatt suffered from Bright's Disease, and in 1882 it killed her. The artist gave this picture to her brother, Alexander, and it passed through several members of the family before ending up at the Metropolitan.

Lydia died after a long final illness during which Mary gave up all thought of painting to devote herself full-time to nursing her sick sister. Mary and her father had both been told by Lydia's doctor that there was no real hope; the once radiant life of that young woman, as seen in Mary's paintings, became a death-watch.

Maybe something of that foreknowledge appears in this picture of the invalid sister in the garden of one of the several country places Mary Cassatt lived in throughout her long productive life in Paris. Certainly Lydia's pale face appears sickly among the richness of flowering nature behind her, beneath the richly tinted white of her bonnet. The border of greens, shrubs, and blossoms leads diagonally back to conservatory windows reflecting the same sort of impingement of color on white that we find with the bonnet.

Oil, 26 × 37"

Gift of Mrs. Gardner Cassatt
The Metropolitan Museum of Art, New York City

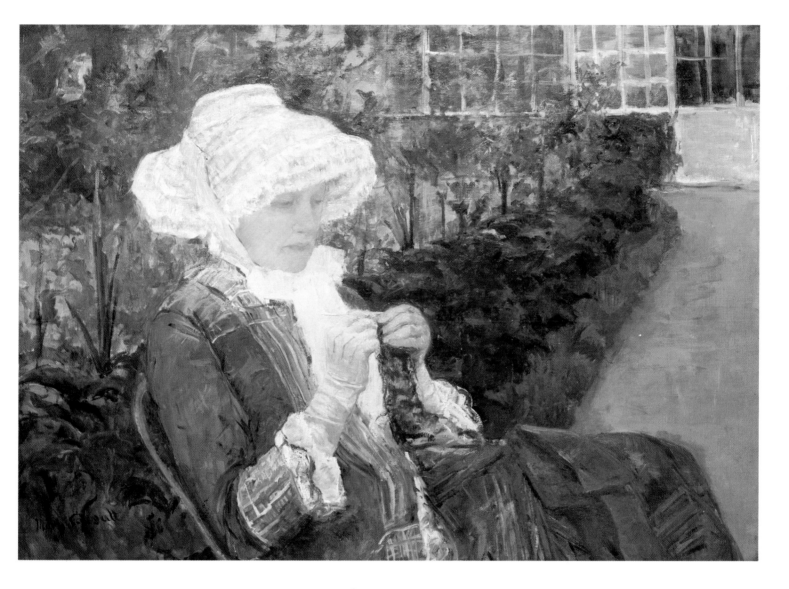

Lydia Reading in a Garden

1880

THERE WAS ONCE A CARTOON of Whistler's mother, in her familiar, seated profile position. With his back to us, her son stood at the window watching furious rain and, brushes in hand, fretting. Said his mother, "Well, Jimmy, if you can't go outside to paint, why don't you paint something inside?"

That, of course, is what Mary Cassatt did all her life in art, whether it was raining or not and whether "inside" was inside the house or inside the private garden, or, for that matter, inside the reserved box at the opera. She painted a private world because she lived in a private world. We constantly see Lydia reading, Lydia crocheting, Lydia weaving, Lydia at the opera, Lydia, as here, in the garden. And Lydia is simply the star in a repertoire company that includes father and mother, brothers, nieces and nephews and their children, and American visitors and French friends, Mary's servants and dogs.

Instinctively she adhered to the principle that you paint what you know. Her so different American contemporaries of the Ash Can School were doing exactly the same thing. A closer parallel can be found in literature. In several important ways, Mary Cassatt did in painting what Jane Austen did in prose fiction.

Here Lydia, dressed for the day and confronting the news of the day, offers a muted contrast in her dress and hair to the riotous blooms of nature behind her.

Oil, 35½ × 25⅝"

Gift of Mrs. Albert J. Beveridge
Art Institute of Chicago, Chicago, Illinois

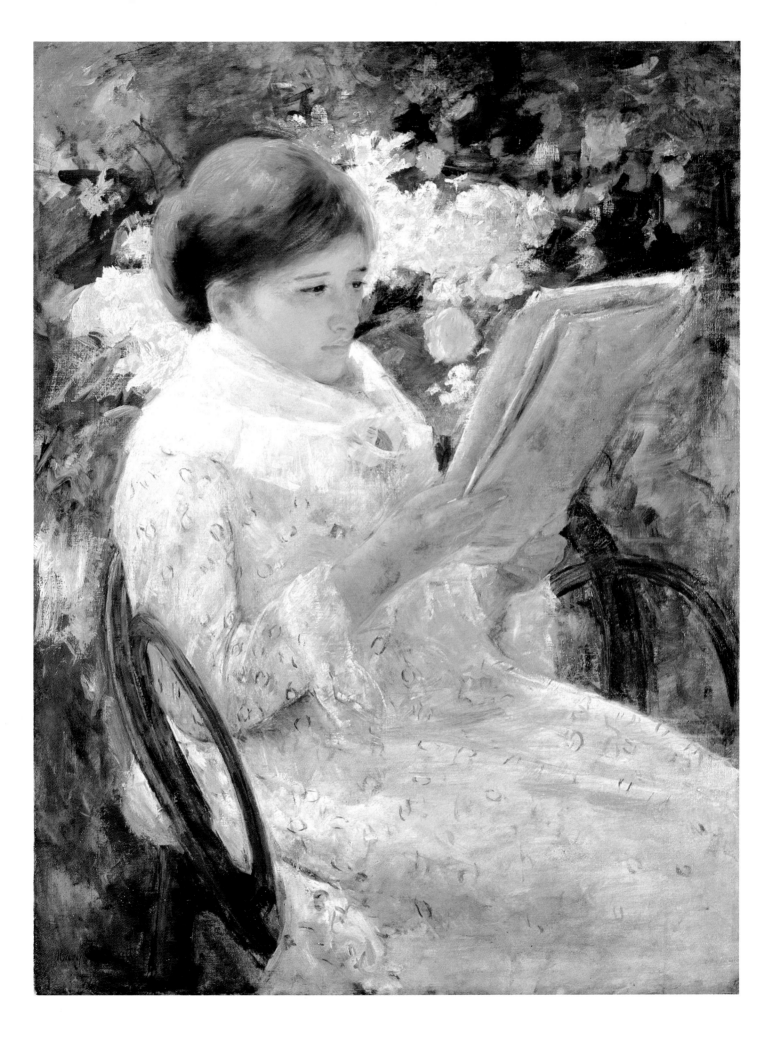

Miss Mary Ellison

c. 1880

Miss MARY ELLISON was a Paris schoolmate of the young woman who became one of Mary Cassatt's closest and most enduring friends, Louisine Elder. This was the young woman Cassatt persuaded to buy the Degas that became the first Impressionist painting to arrive in America. When Louisine Elder became Louisine Havemeyer, Cassatt traveled with the Havemeyers and guided them in building a great collection of Old Masters as well as Impressionists. The Havemeyer pictures are now mostly in The Metropolitan Museum of Art. As a friend and classmate, Miss Ellison was present at the beginnings of that friendship so fruitful for art in America.

Here she sits, presumably in the Cassatt apartment, fan spread for reasons of ornament rather than for any of the many other purposes used by Victorian young ladies. She is relaxed, a little grave, the back of her head reflected in the glass, her green dress topped with ruffles and jabot at the throat.

Mirrors have always fascinated a certain kind of artist. The glass repeats the present world but does so backwards. Or, as with Alice, it opens a new, strange, sometimes alarming and always intriguing world. Mary Cassatt used mirrors regularly, though usually very subtly. In the opera loge pictures, for example, you often have to look closely to realize it is a mirror behind the sitters, not just the next box. In painting the mirrors at the opera, of course, Cassatt was achieving in her own intimate way what Manet was doing at the same time in his bravura performance in the *Bar at the Folies-Bergères*. One of the great mirror pictures of all time was painted by one of Mary Cassatt's special artist-heroes, Velàsquez.

As is customary with Cassatt, the mirror is off center and so is our point of view, so that we see the second Mary Ellison behind the first, staring off into that private space as invisible to us as the space of the artist and ourselves.

Oil, 33¾ × 25¾"

The Chester Dale Collection
The National Gallery of Art, Washington, D. C.

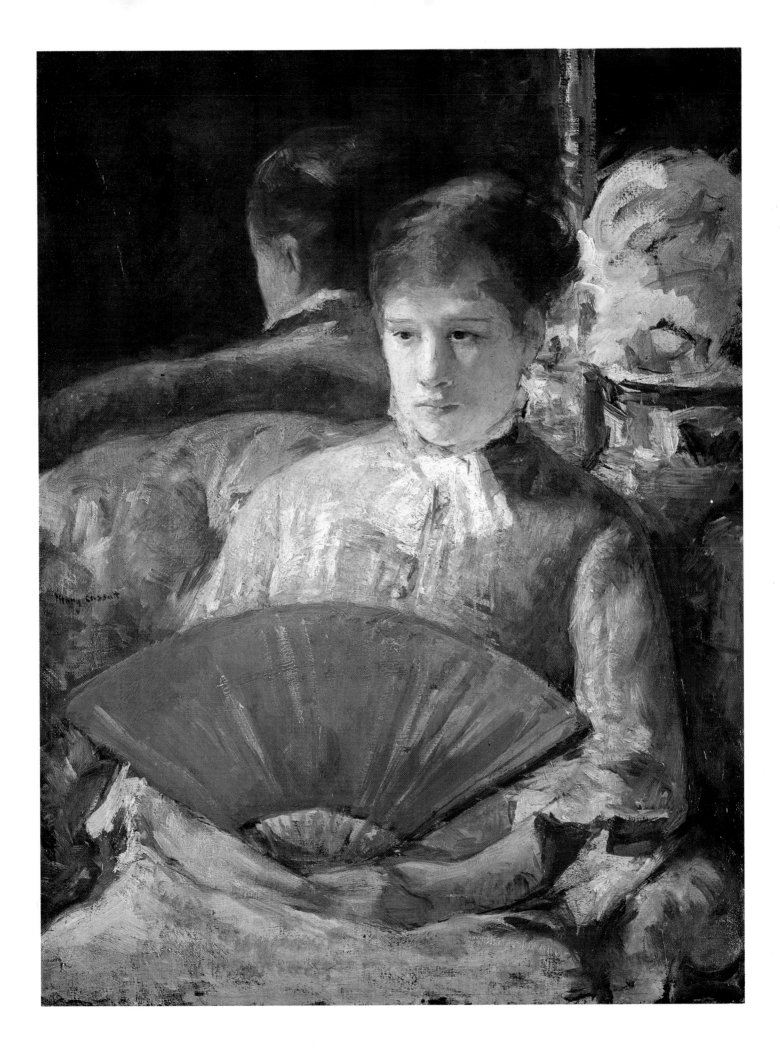

Mother About to Wash Her Sleepy Child

1880

THIS MAY WELL BE THE EARLIEST EXAMPLE of a major theme in Mary Cassatt's work, that of mother and child. It was a theme to which she would return again and again, for it expressed very clearly her own view of the highest achievement a woman could attain, and one which she profoundly regretted never having attained herself. Inevitably a nineteenth-century unmarried woman artist suffered deep doubts on the subject of marriage and motherhood. Mary Cassatt never entirely resolved hers, saying in her old age that her great mistake was to have chosen painting instead of maternity. Out of that conflict came, of course, the greatest body of work on the mother-and-child theme since Raphael.

These two figures typify Mary Cassatt's approach to this universal motif so often the subject of the most blatant sentimentality. As far as her work was concerned, there was not a sentimental bone in Mary Cassatt's body and the same was probably true of her personal relations. She painted what she saw, just as she said what she thought—neither course particularly popular or commonly practiced, then as now.

The mother picks up the washcloth and looks at the infant she is holding with her other arm. She clearly loves the child, but she is just as clearly a woman of purpose intent upon a necessary task. As for the sprawling child, it, too, gazes at its mother with what passes for love in infants, namely a sleepy, satisfied recognition of the source of food and care. The white shift of the baby and the gray dress of the mother contrast effectively with the wallpaper background. Incidentally, that wallpaper pattern, as well as the floral decoration on the basin, seem to have an independent existence of their own, an effect Cassatt chose quite regularly and which became an element essential to the work of the next generation of French painters, the generation of Picasso, Braque, and Matisse.

Oil, 39½ × 25¾"

Mrs. Fred Hathaway Bixby Bequest
Los Angeles County Museum of Art, Los Angeles, California

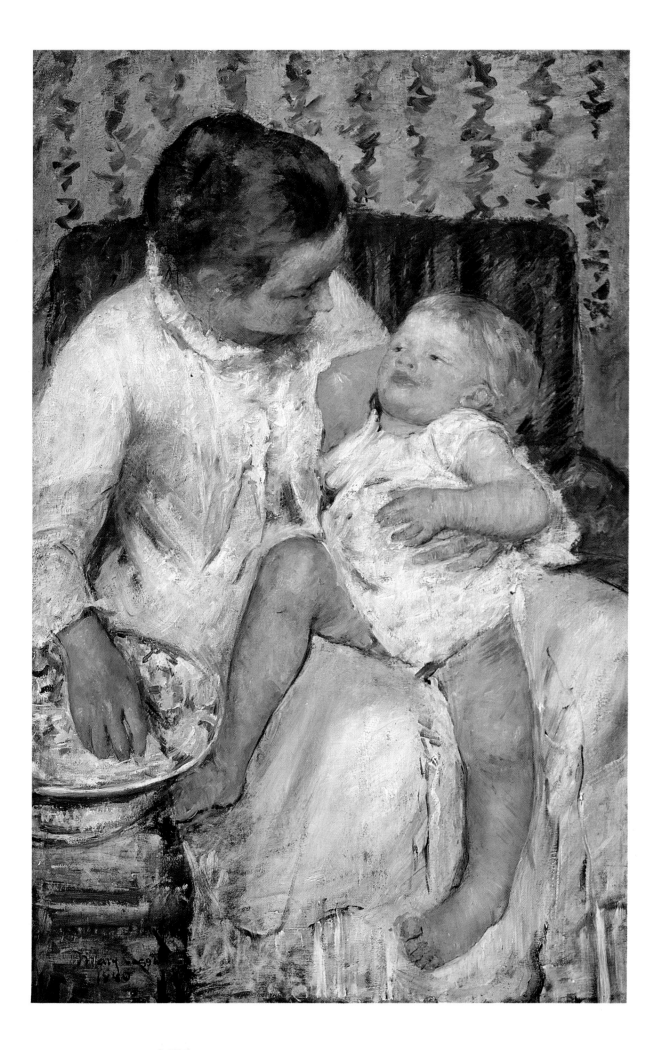

Lydia Working at a Tapestry Frame

c. 1881

LYDIA, INTENT ON HER WORK, is held as securely as the tapestry in its frame by the hardness of that frame in front of her and of the dark wood piece of furniture behind her—and by the contrasting softness of the upholstered chair to the right of her, the green and rose chintz drapery to the left. The whole ensemble is glowingly illuminated by daylight filtered through the window curtain. The abstracted gaze and pale face thus framed by hard and soft surmounts a body clothed in a print of warm roses and green leaves. The four principal visible fabrics underscore the fact that the subject is the creation of a fifth fabric, largely invisible, on the formidable frame.

The light from the window in the first place dazzles all over the curtain in a spectacular piece of painting, shimmers across the top of the polished tapestry frame and splashes onto Lydia's left shoulder and chest, washing out the rose ground of the rose dress, causing the blossoms there to seem as if fallen on snow.

Somewhere in the Cassatt family's past along what had been an American frontier near Pittsburgh, the women no doubt practiced home manufacture of fabrics. But the family had left such labors behind long ago. Lydia's practice of tapestry-weaving was something else: the accomplishment of a proper Victorian lady, even if it was a little heavy, too elaborate, for a time more suitably filled with knitting or crocheting—which Lydia, of course, also did. However, the craft revival, sparked by the evangelism of William Morris, was in full swing. Lydia's tapestry-weaving relates to that phenomenon, a phenomenon that would shortly blossom into Art Nouveau and continue on into the flourishing contemporary craft practice on both sides of the Atlantic.

However genteel this practice might have been, it was clearly part of an early reaction to the new age of manufacture, then at flood tide.

Oil, 25¾ × 36¼"

Gift of the Whiting Foundation
Flint Institute of Arts, Flint, Michigan

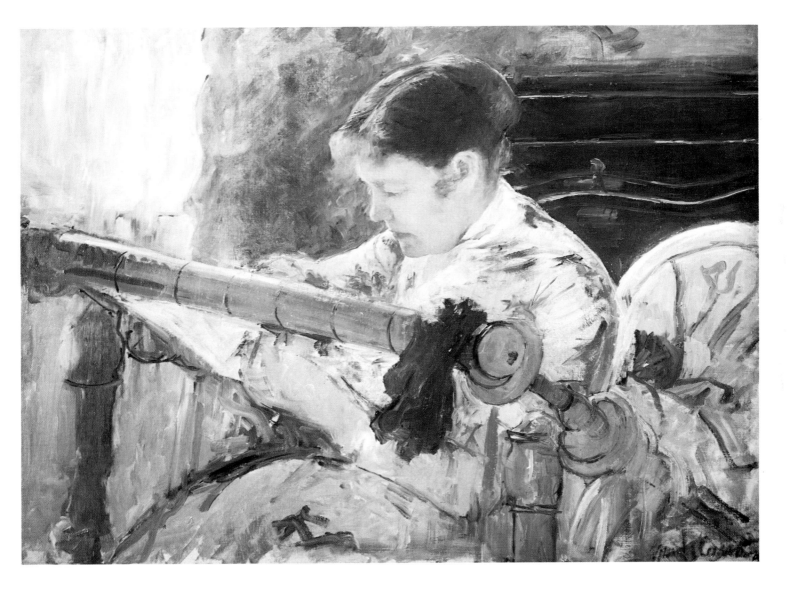

Susan Comforting the Baby (No. 1)

1881

ALTHOUGH IN PROFILE, without a bonnet, and somewhat sketchily painted, the young woman can still be recognized as the Susan of the Cassatt masterpiece *Susan on the Balcony Holding a Dog*. This is not as elaborate a painting, but it quietly and exquisitely captures the changing feelings of a young adult and a baby who apparently has just given itself a blow on the head, presumably by falling over in the carriage. Still feeling the hurt, the baby is already being distracted from it and is awakening to the comforting presence of someone who cares. Susan is entirely preoccupied with the infant's tiny troubles, and the two heads come together in an affectionate touch.

Set against the green of the background foliage, the woman and baby are further set off by the whites and by the blue details of their dresses.

There is another version of this picture, in a private collection, in which the surrounding foliage plays a larger part. It is brilliantly painted, but the rapport between the two figures is by no means as close.

Oil, 17⅛ × 23"

Bequest of Frederick W. Schumacher
Columbus Museum of Arts, Columbus, Ohio

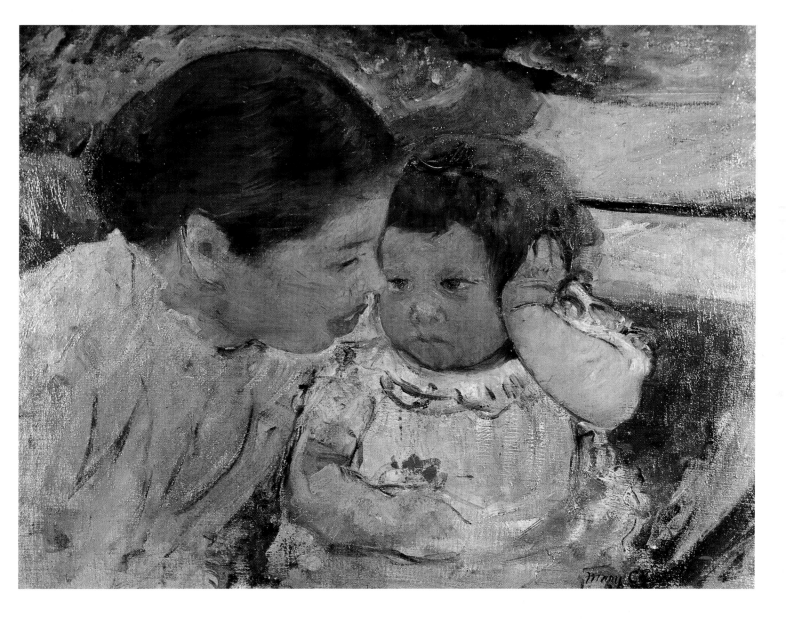

Two Young Ladies in a Loge

1882

MARY CASSATT'S PASSION FOR OPERA began very early and lasted all her life. The Paris Opera was surely one of the chief attractions the city had for her. She went to the opera often, just as she entertained visiting Americans and spent time in her garden. All three activities turn up regularly as the subjects of her paintings. Unlike Degas, however, Mary Cassatt did not paint the scene on the stage, nor the orchestra in the pit. Instead, she painted the people watching the spectacle, hearing the music, usually people she knew and with whom, presumably, she had gone to the opera.

Here the two young ladies are Mary Ellison, the brunette, and the blond daughter of Casatt's friend, Stéphane Mallarmé, the poet. They are models of decorum, sitting erect, gravely attentive to the opera on the stage, their contrasting heads framed by the great curves of the tiers behind them and by the bottom of the central chandelier, cut off in the upper right corner of the picture. Both young ladies bear flowers, Mlle. Mallarmé a small bouquet wrapped in tissue paper, Miss Ellison a painted bouquet on her wide-open fan, which hides her mouth and chin.

There is a pastel study for this oil in Cincinnati. The two works together show Cassatt's drive for dramatic placement of her figures. In the pastel, the young ladies are presented more nearly full length. The person behind them, although more vaguely depicted, looms much larger, and there is much more of the chandelier visible. In the oil, Cassatt has, in effect, moved her point of view in close, in a way perfectly analogous to camera work, to remove extraneous surroundings and emphasize the two decorous operagoers.

Oil, 31⅛ × 25⅛"

The National Gallery of Art, Washington, D.C.

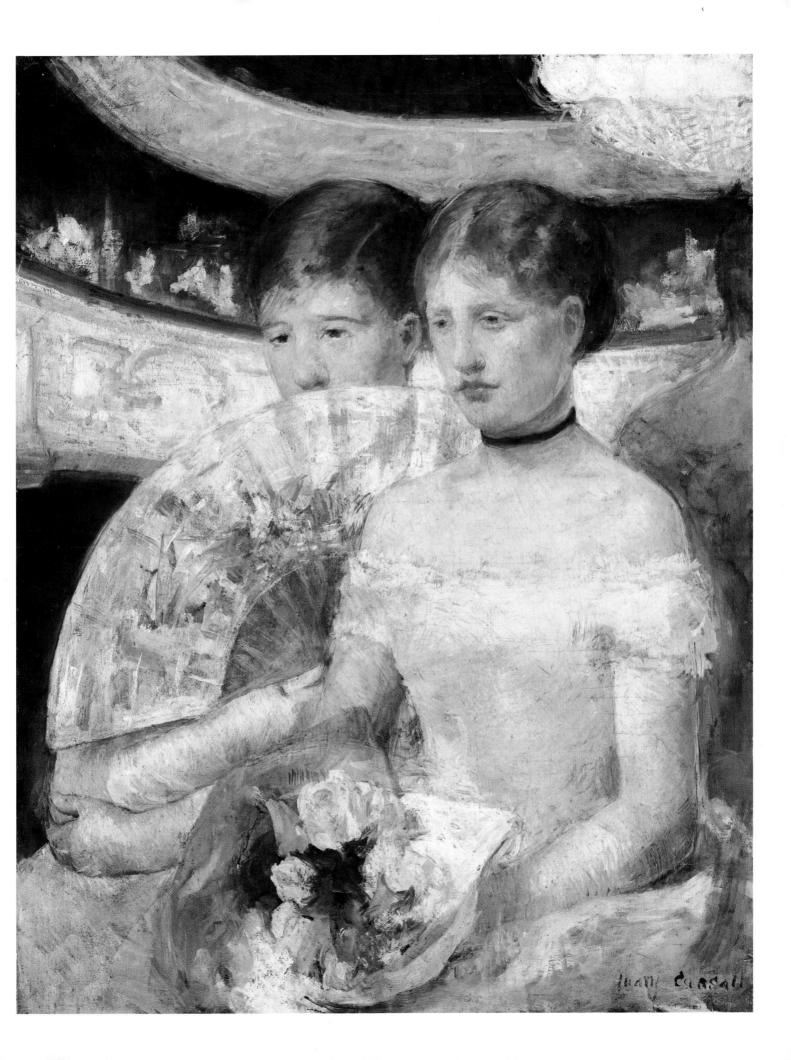

Lady at the Tea Table

1883-85

IF MARY CASSATT HAD GIVEN HERSELF HALF THE AIRS assumed by her fellow-American expatriate, James A. McN. Whistler, this magnificent portrait might well have been titled, *Variations in Blue and Gold*. In the Whistlerian sense, it *is* a suite of such variations: the blue of the Canton china service picking up the lights from the cloth, the sitter's deep blue frock contrasting both with the china and the paler blue of the wall, the white lace carrying its own blue reflections and, dominant, the sitter's blue eyes.

But the picture is a good deal more than that and, of course, Mary Cassatt had no such airs. For her it was a portrait and, in the end, a disappointing one: the subject is Mrs. Robert Moore Riddle, a Cassatt family connection. After two years of the artist's work, the family was disappointed. Mary Cassatt was disappointed at their disappointment and stored the picture in a closet, where it was found by Mrs. Havemeyer and subsequently exhibited, at Durand-Ruel, Paris, in 1914. Nine years later, forty years after it was begun, Cassatt gave the picture to the Metropolitan, exemplifying a basic truth about portraits: if the family finds the likeness unacceptable, a great museum may rejoice to have it.

Beyond the endlessly varied blues and their accents and boundaries of gold, the painting has tremendous architectural solidity. The rectangles of the wall frame the roundness of Mrs. Riddle; the tea service brings together those equal and opposite solidities.

The portrait surprisingly recalls those colonial dames painted by Stuart and Copley before their own expatriation, with the plain, straightforward face in the midst of a perhaps not entirely familiar elegance. Even in such revolutionary change as Cassatt consciously, if conservatively, pursued, an American continuity asserts itself.

Oil, 29 x 24"

Gift of the Artist, 1923
The Metropolitan Museum of Art, New York City

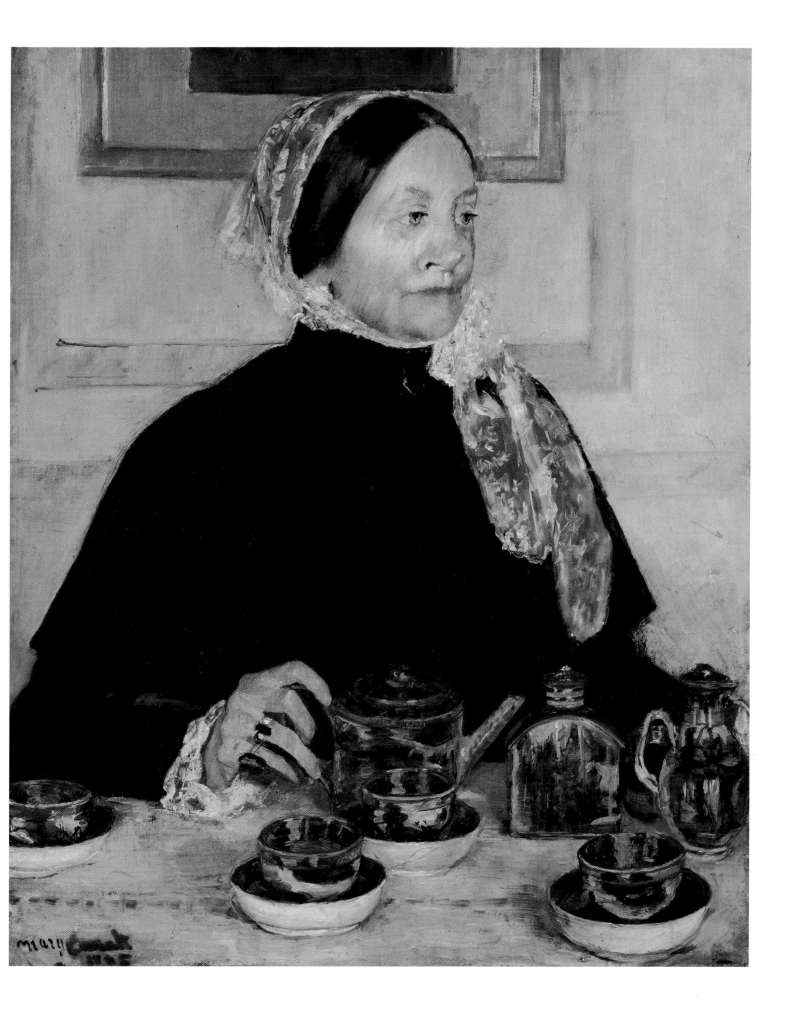

Susan on a Balcony Holding a Dog

1883

ODDLY ENOUGH, we know more surely who the dog was than who Susan was. The dog, Batty, was Mary Cassatt's, one of a long line of Belgian griffons she owned. Susan was probably the cousin of Cassatt's housekeeper, Mathilde. At any rate, here she sits on the Cassatt family balcony with its view of Montmartre in the distance, dressed up for the visit and perhaps not quite at ease being painted. There is a touch of what might be self-consciousness in both her face and bearing that almost never appears in Cassatt's sitters.

In painting after painting she establishes herself as the virtuosa of white. Her secret is simply that in the real world, as opposed to color charts or color laboratories, white is almost never just plain white, whether in a snowfall or a tablecloth, or here, in the frock and hat worn by Susan.

The hat reminds us of what both life and art lost when women started wearing cloches, while Mary Cassatt was still alive, and later, wearing no hats at all. Quite apart from the numerous subtle blues, pinks, lavenders, and grays Cassatt saw in that white gauzy headpiece, consider the marvelous effects on the face of the light filtered through the gauze and, just where the chin becomes jaw, reflected upward off the hat ribbon onto the skin. The dress itself is a fugue on the theme of white, set off nicely by the brown-beige of the dog's hair, Susan's long gloves, and the wicker of the balcony chair.

Oil, 39½ × 25½"

Corcoran Gallery of Art, Washington, D.C.

46

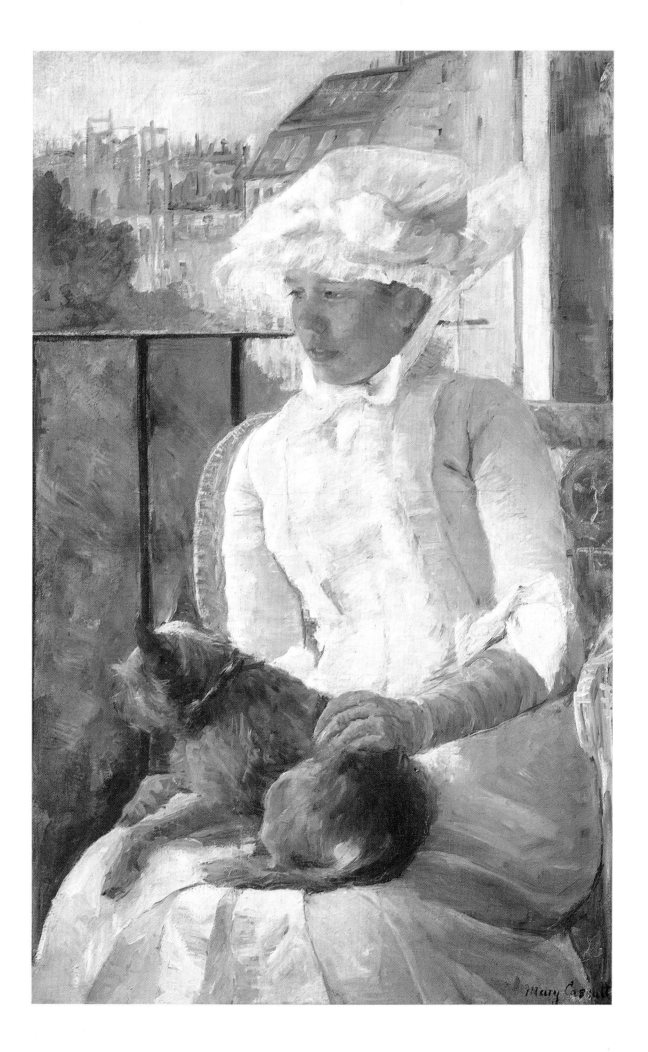

Young Woman in Black

1883

ONE OF THE MORE EXTREME IMPRESSIONIST *dicta* proclaimed: "There is no black in Nature"—a perception obviously originating with a man who had never been down a coal mine, held an ebony carving, or been chased by a black bear. However, the dictum had its uses—reminding painters, for example, that shadows are by no means as black as they had been painted by the French academics who dominated the art world that the impressionists were trying to crash. But that overstated rule was blithely ignored by Mary Cassatt, who wore black clothing and painted black as naturally as many of her friends.

Here the young woman is a symphony of blacks, each slightly distinct from the others by reason of its material or differences of light: the costume itself, the hat, the bird's wings upon it, the veil that covers but does not hide most of her face, the gloves, and the black jet purse. Highlighting and pulling together all those black tones is the surprising splash of pink in the little bow at her throat. The device works as well in the painting as it surely did for the ensemble.

Just as the pink splash is heightened by all the black, the black itself is heightened by the background, thoroughly nonblack and in contrast to the costume, rather spread out, diffuse: the casual floral print in red and green on the chintz slipcover of the chair, for instance, against the paneled wall. Typically, Cassatt presents the single object of art, the framed fan—very popular among the impressionists—cut off in the middle and off-center both in the picture and in relation to the sitter.

The young woman herself is typical of the inhabitants of the world of Mary Cassatt, self-assured, interested in a conversation with someone "off-camera," possibly the artist, good-looking rather than a beauty.

Oil, 31¾ × 25½"

The Robert Gilmor, Jr., Collection, Courtesy of the Baltimore Museum of Art
The Peabody Institute, Baltimore, Maryland

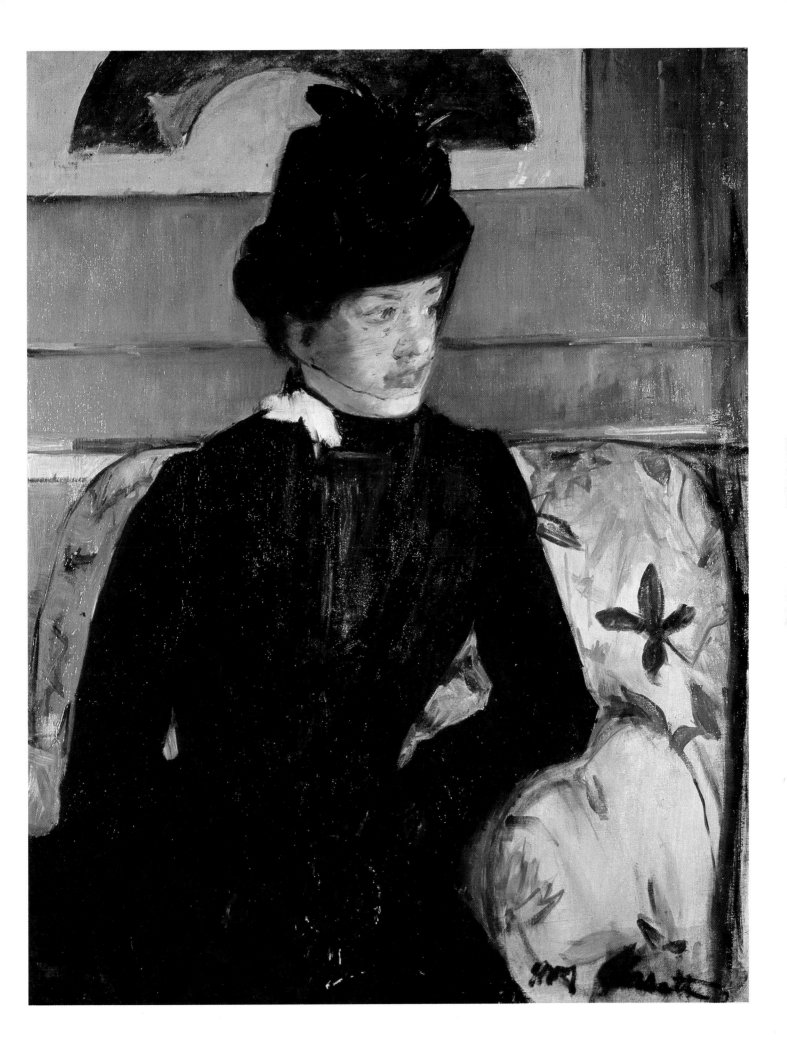

Portrait of Mr. Alexander J. Cassatt
and His Son Robert Kelso

1884

Mary cassatt is the only American artist of note who went to live and work in Paris and brought her family along. Partly because of Victorian mores about well-brought-up single women, partly because she *was* well brought up, and partly out of family affection, Mary Cassatt lived in Paris just as much in the bosom of her family as if she were still in Philadelphia. She was a very good daughter to her parents, and a sister to her brothers and sisters, all of whom she frequently painted.

Her brother Alexander, unlike her sister Lydia, was never a regular resident in Mary Cassatt's various Paris apartments and country places. He did come over from Philadelphia for visits, sometimes extended ones; once he stayed for a year and a half. But his work was at home. Some of the less successful Impressionists who thought Mary Cassatt was rich, resented the fact that she did not single-handedly pay the expenses for their several exhibitions. They talked loosely about her father as an American railroad president. Actually her father, although certainly "comfortable," as was said at the time, had no great fortune nor, in the course of his life, did he ever do much to increase his competency. It was his son, Alexander, who was the railroad president.

Toward the end of 1884, Alexander wrote home to his wife, who never really got along with his sister, "Mary has commenced portraits of Robert and me together, Rob sitting on the arm of my chair. . . . I don't mind the posing as I want to spend several hours a day with Mother anyhow and Rob will not have to pose very much or long at a time."

Rob was named for the brother of Alexander and Mary who died while the family was in Germany. The family resemblance is very strong, especially in the eyes of father and son.

Oil, 39½ × 32"

W. P. Wilstach Collection and Gift of Mrs. William Coxe Wright
The Philadelphia Museum of Art, Philadelphia, Pennsylvania

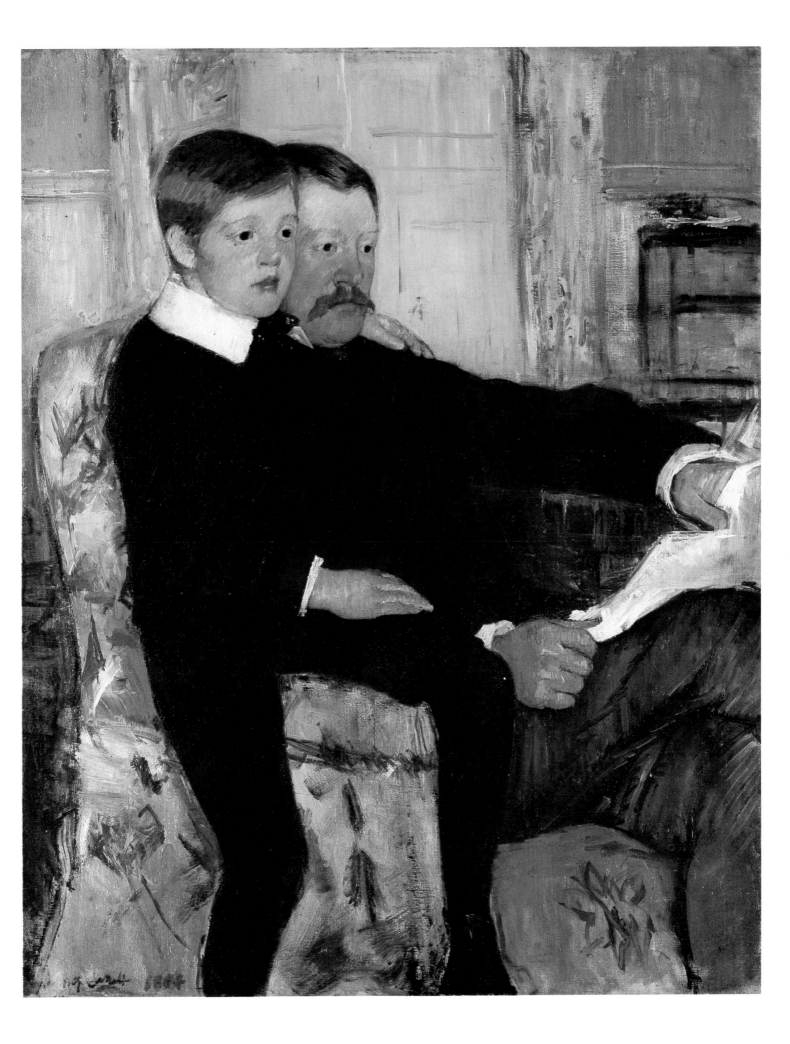

Two Children at the Seashore

1884

THIS PAINTING POWERFULLY ILLUSTRATES a strength of Mary Cassatt, one that is very close to the heart of her genius: almost nobody in her pictures seems to be sitting for a picture. This is a very special virtue when children are the subject. In the photography of her day, children and adults, too, were still clamped into place—held still by adjustable clamps fitted to the head—while the reflected light made its marks on the plate. In fact, of course, this was not really the invention of photography. It had been the universal practice of portraiture for as long as portraits had been painted. In painting, the clamps were invisible. No iron or steel was needed. The subject provided the psychological clamp. You can see its stiffening effects in all portraits except those by the greatest painters in the field, from Raphael to Sargent. In the portraits of lesser painters, many of the sitters are either on the point of going to sleep or as tense as if a rattlesnake were winding round their feet and they were unable to move.

Cassatt cuts through that whole tradition in a way entirely her own. She simply sees people being people, not people being sitters for portraits. That is close to impossible with children, but Cassatt does it always.

Here, both children are utterly self-absorbed. Unaware of the sea behind them, the boats going by, the soft crash of waves, they play with the sand, a marvelous material for children or grownups, infinitely malleable in contrast to most of the things or persons we encounter. In their similar pinafores, they almost seem to be the same child, turned 90 degrees in a double exposure.

Oil, 38⅜ × 29¼"

Ailsa Mellon Bruce Collection
The National Gallery of Art, Washington, D. C.

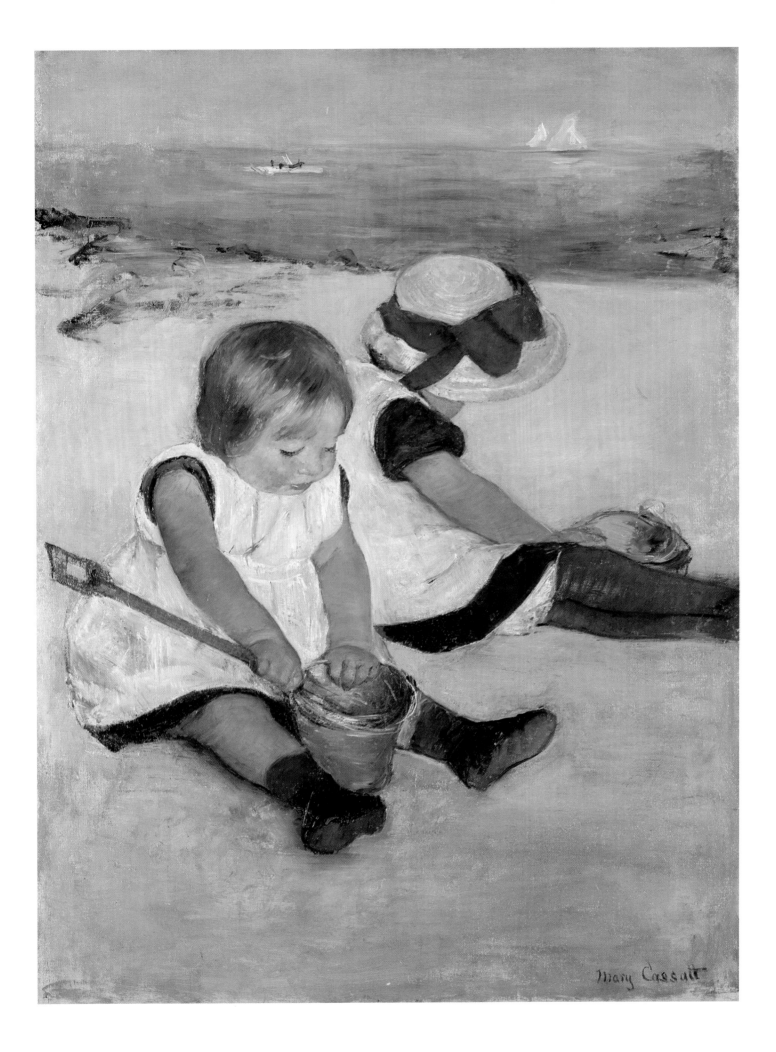

Woman and Child (Mathilde and Robert)

c. 1885

THIS IS A RARE BRINGING TOGETHER of two entirely different sets of persons in Mary Cassatt's life and work—a member of her family, her nephew Robert Kelso Cassatt (Alexander's son), and her loyal, long-time housekeeper, Mathilde Vallet. Cassatt painted members of her family throughout her career. And, once she was established in Paris and in a series of French country houses, she painted her servants and the peasants and townsfolk of the surroundings. This may be the only picture that brings together both her worlds.

Frederick A. Sweet, whose book on Cassatt is basic, quotes a letter from Mary's mother to her granddaughter Katharine: "I tell (Robbie) that when he begins to paint from life himself, he will have a great remorse when he remembers how he teased his poor Aunt wriggling about like a flea." To this Adelyn D. Breeskin, the other essential Cassatt scholar, adds, "Here Mathilde seems to be trying to keep him from wriggling." We see that in the firm clutch of the housekeeper's hand on the boy's neck and jaw and in her other hand resting on his right hand. It is interesting to contrast the determination and control in this picture with the apparent ease and relaxation of Robert's pose pictured with his father (*Portrait of Mr. Alexander J. Cassatt and His Son*, 1884).

This picture is splendid in the relation between the two figures and in their relations to the background, which is an unusually deep one for Mary Cassatt.

The glances of the woman and the boy, while readily explainable in the terms suggested by Sweet and Mrs. Breeskin, have a nice, lively dynamic of their own: She is staring over his head, somewhat grimly perhaps, he is looking straight at the painter, and at us, to begin a zig-zag series of diagonals through the picture worthy of Tintoretto, though more subtle. The "zig" of the boy's glance attaches to the "zag" of the housekeeper's. The line continues from her eyes along the near shore of the lake in the background and then returns left along the distant shore.

Their costumes contrast as well as their glances. His dark, heavy suit—not the dark Eton suit of the portrait with his father—leans against the light mauve Mathilde wears, a mauve shot through with white, which culminates in the white yoke and which, in the body of the dress, is so lightly painted as almost to seem a separate, covering garment over the mauve.

The picture was bequeathed to Mathilde by Mary Cassatt and was sold in the "Mathilde X" sale in Paris.

Oil, 28¾ × 24"

Felix Fuld Bequest
The Newark Museum, Newark, New Jersey

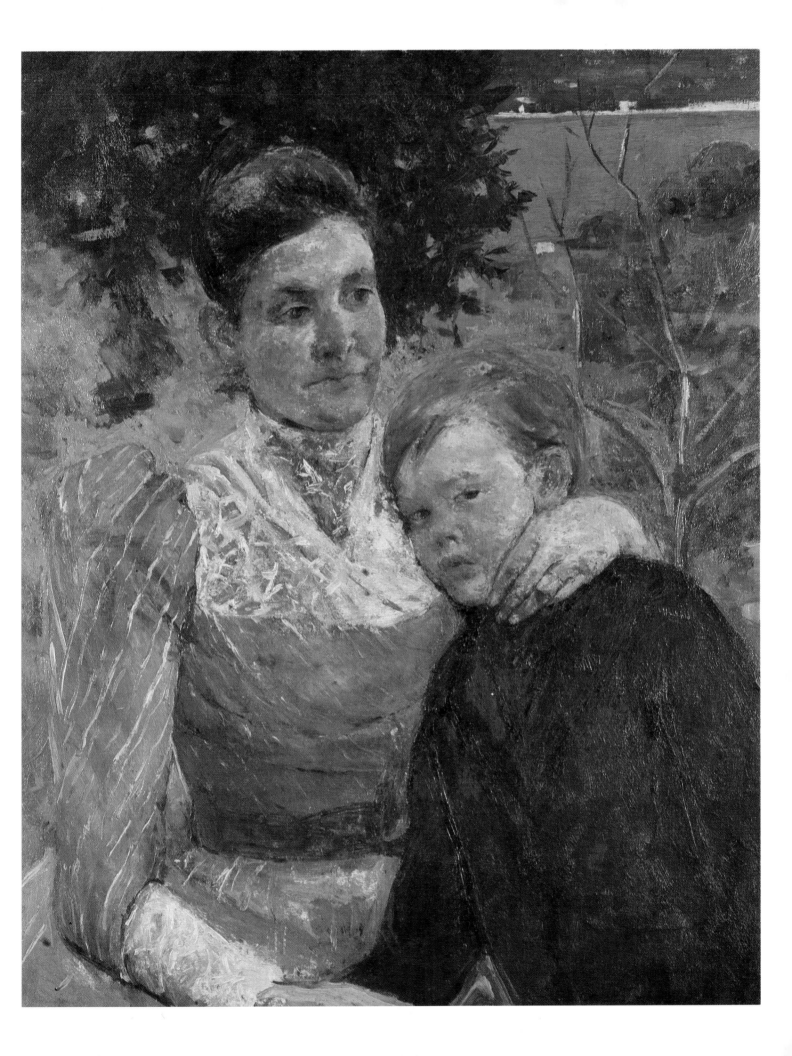

The Family

c. 1886

Mary cassatt was not the only turn-of-the century painter to celebrate motherhood. She was, however, the only great painter to celebrate motherhood. The others, all over the Continent, in England and America, sentimentalized a subject intrinsically provocative of the sloppy thinking and false perception that is sentimentality, and they idealized a subject that needs no idealization. Mary Cassatt saw what was in front of her instead of what the Victorian ideal of motherhood and childhood told her she ought to see; and what she saw she painted.

Occasionally, though, she, too, painted in a way that almost embarrassingly suggests such cocelebrants of motherhood as her fellow-American Abbott Thayer, and the English Pre-Raphaelites. This is such a painting, and it can be said at once that the hint of a resemblance comes from two things, both unusual in Cassatt. One is the overall lighting of the faces, and the baby's body, in what the theater calls Schubert pink, a self-explanatory name. Nature, fortunately, is incapable of good taste and is as capable of Schubert pink as were the Schuberts. The other is the rapt expression of the young girl holding a pink flower in a way that suggests the real Pre-Raphaelites of the early Renaissance. The answer here is simply that young girls, like all of us, sometimes do slip into that faraway look. In the painting, that potential mawkishness is stopped before it begins by the quizzical look the baby casts on the girl. Also, of course, the sturdy pyramidal figure composition is found in similar subjects by those completely unsentimental painters, Leonardo and Raphael himself.

Oil, 32¼ × 26⅛"

Gift of Walter P. Chrysler, Jr.
The Chrysler Museum, Norfolk, Virginia

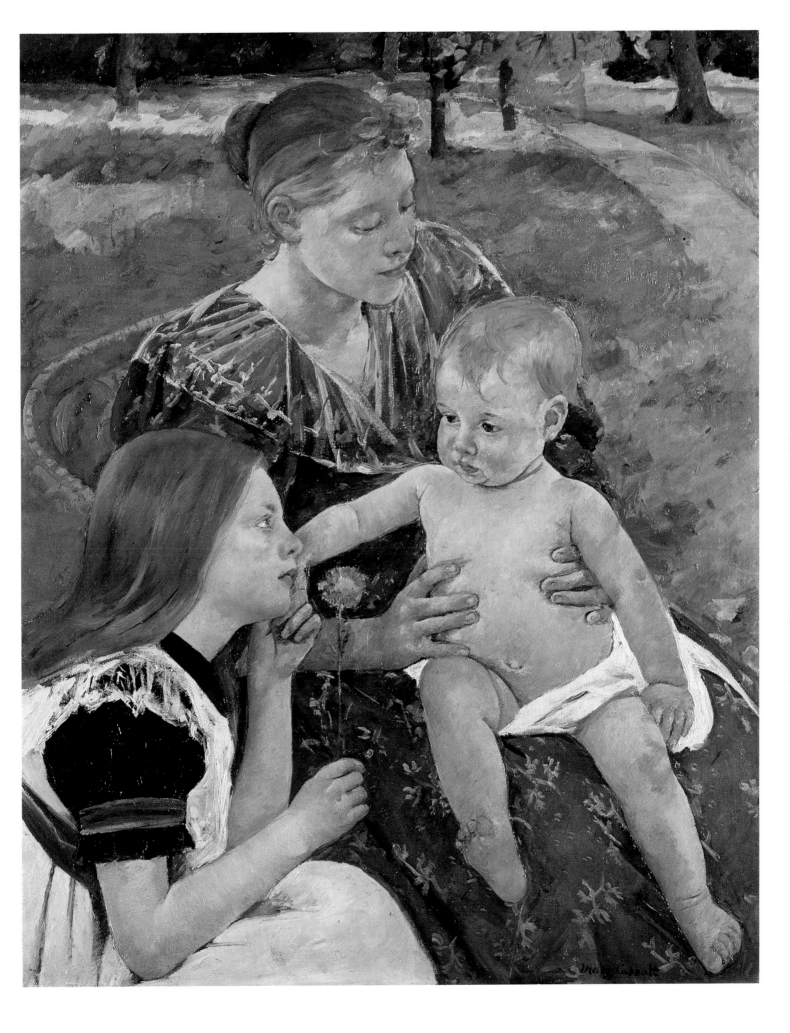

Girl Arranging Her Hair

1886

THIS PAINTING CREATED TWO SENSATIONS, both having to do with Degas. The story goes that Cassatt and Degas were having one of the regular quarrels over art that punctuated their close and enduring friendship. Degas, who was an unrepentant chauvinist, announced abruptly that women should not express opinions about style since they had, and could have, no idea of what style might be. Cassatt, infuriated as she often was by such sexist pronouncements from her friend and mentor, resolutely took to her studio to produce a painting that even Degas would admit had that elusive, hard-to-define quality. The result was *Girl Arranging Her Hair*. It was exhibited in the eighth and last of the Impressionist exhibitions and drew special praise from most of the knowledgeable people who attended. One such was Degas himself. Stopping before the painting in the show, he exclaimed over its virtues, concluding, "What style!" The quarrel was over. Degas acquired the painting for his large collection, and when he died, the painting was again a sensation at the estate sale, where at first it was taken for one he had painted himself.

Indeed, he might have. The model has that raw-boned ungainliness that Degas faithfully found and reproduced even in dancers and race-horses, two of the least ungainly creatures there are. Like them, the girl here has a grace of her own—or of Mary Cassatt's—beneath the apparent awkwardness. The two arms joined by the coil of brown hair form the elongated S-shape that William Hogarth, the English painter-engraver, theorized was the very essence of beauty. Beyond that, there is an almost sculptural quality to the shapeless chemise while the rigid bamboo of chair and mirror strongly frame the girl. As Degas said, "What style!"

Oil, 29½ × 24½"

Chester Dale Collection
The National Gallery of Art, Washington, D. C.

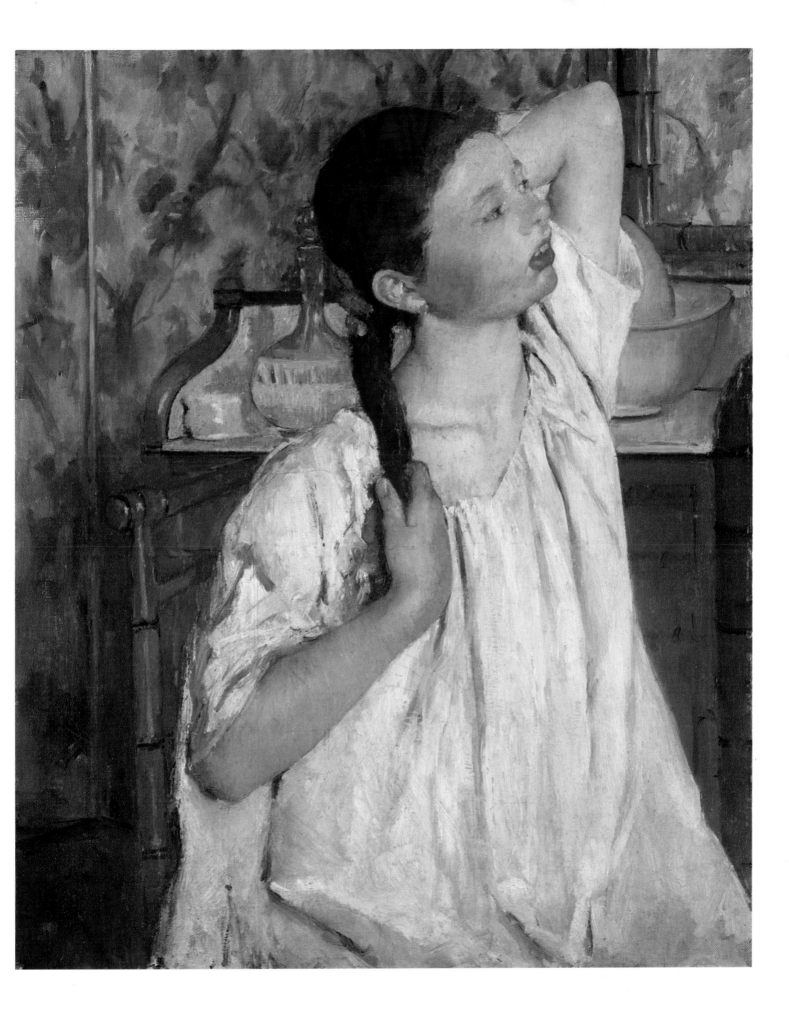

Little Girl in a Big Straw Hat and Pinafore

c. 1886

THIS PORTRAIT STUDY of a young girl is unique in Cassatt's whole body of work, with its dozens of paintings of children of various ages and dispositions. Here, it is the disposition rather than the age that is so special. Although almost certainly one of the French neighborhood children Cassatt recruited for her painting, somehow this child comes across as American in a way that most of the children in her work are clearly not. In the way she holds her hands, slumps her shoulders, stares glumly off to our right, not meeting our eyes, this little girl is—allowing for changes of age, sex, and time—Huckleberry Finn either in a dismal moment of being caught out at something he shouldn't have been in, or in a scarcely less unhappy moment of realization that the grown-up world really is as discouraging as grown-ups keep saying it is.

It is worth recalling that at one point, while painting two of her nieces, Mary tried to ensure their quietness by having their mother read the Mark Twain novel to them. It didn't work because Mary herself kept bursting into laughter. And so do we, here—at that charming, faintly preposterous look of bafflement, frustration, and patience on the face and in the figure of this junior Miss Huck.

It is rare indeed that Mary Cassatt painted anyone at all without a background of some kind, a conjunction of lines of furniture and walls, a splash of garden colors. Here the gray-tan background of nothing at all is more than justified by the character and the emotion of the moment distilled into face and form.

It is not without significance that this picture was owned at one time by Ambroise Vollard, the great twentieth-century Parisian art dealer; at another time by Mr. and Mrs. Paul Mellon, the great American collectors and benefactors of art in this country.

Oil, 25½ × 19¼"

The National Gallery of Art, Washington, D. C.

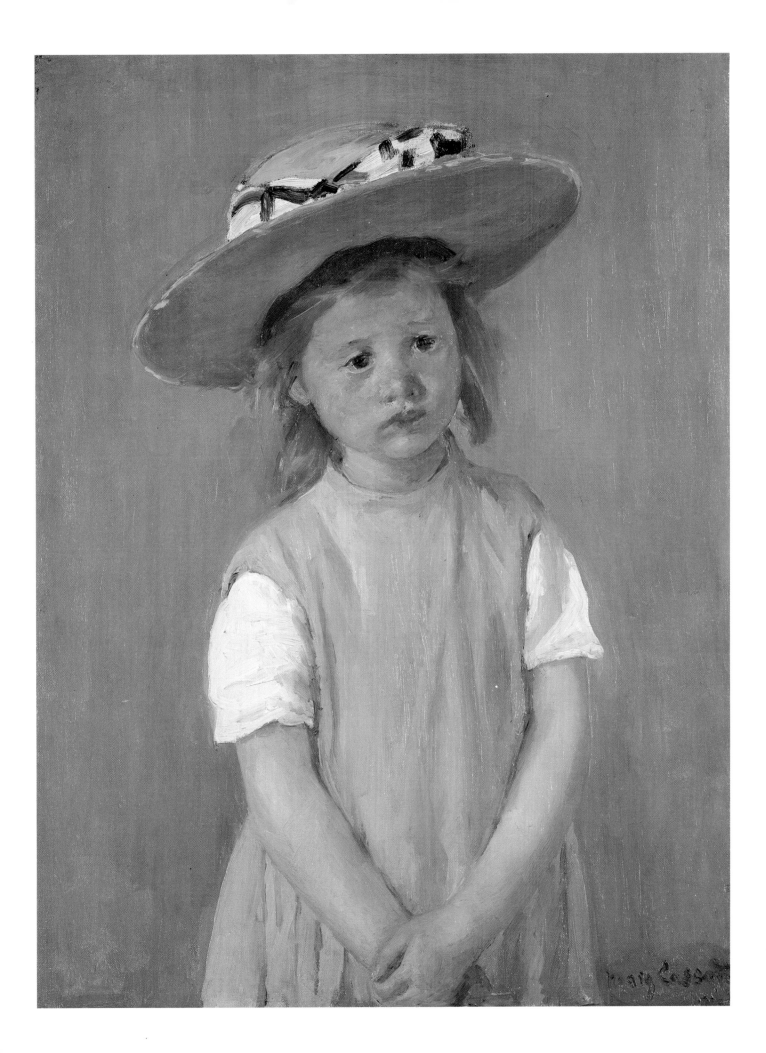

Young Woman Sewing in a Garden

c. 1886

THIS MAJOR PICTURE—rarely, if ever, seen in America—comes from the middle of Mary Cassatt's golden decade, when she was producing as never before, and when it seemed she could do nothing but get better, deeper, more varied, and more in command of her talent. It is the embodiment of Cassatt's work of the eighties.

As she does elsewhere with this typical domestic subject, the artist concentrates the picture the same way the model concentrates her own efforts. Eyes cast down to the task, she watches every stitch of what actually, despite the title given the painting, seems to be tatting or some other form of cloth creation rather than sewing as such. Yet how wonderfully the painter surrounds her with that frame of nature, how splendidly nature's colors complement the neutral quality of the work, the pale blue of the dress.

The dress and the model's nondescript brown hair are set in a hotbed of red geraniums against the greens of field and foliage in the distance. Similarly, the solid, stable balance of the sitter in her symmetrically backed garden chair is played against the steep diagonal of the hillside—in much the same way as Cassatt was accustomed to doing with chair rails, dressers, and washstands in her interiors.

As always when confronted with one of Mary Cassatt's too few exteriors with figures, we experience a slight pang of regret at the entirely different and separate body of work she might have left us had she just gone out of the house more often.

Oil, 36 × 25½"

Antonin Personnaz Collection
Musée du Louvre, Paris, France

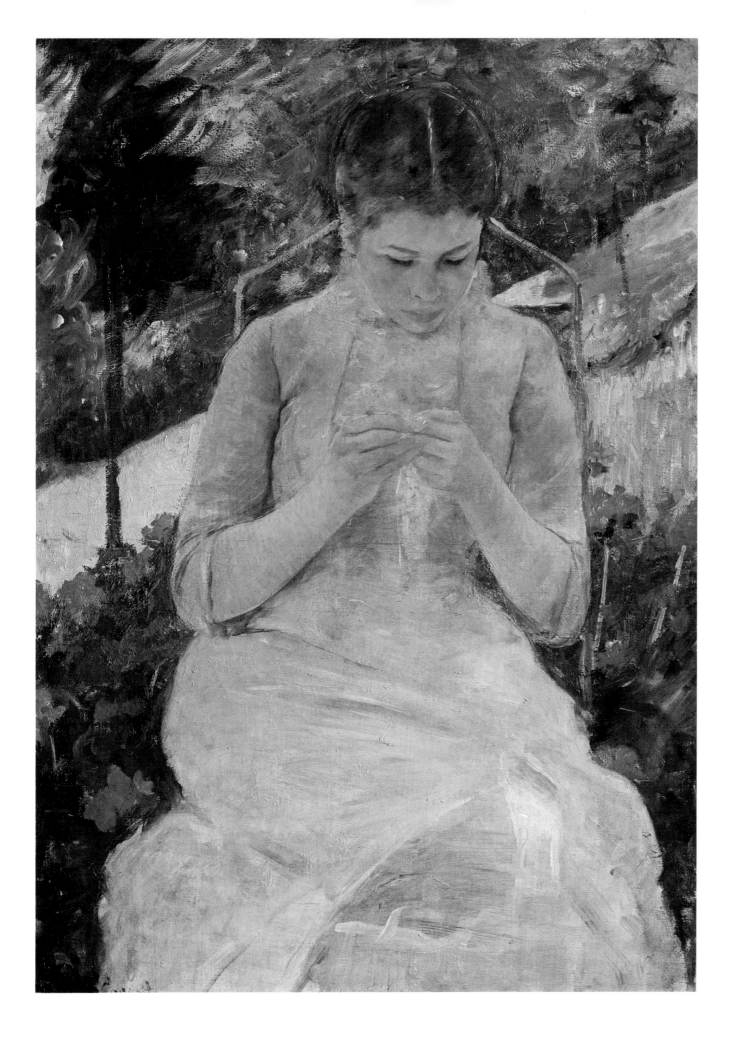

Portrait of an Elderly Lady

c. 1887

ELDERLY SHE MAY BE, but the spark of life burns as brightly in this sitter's eyes as it did for Mary Cassatt in her long old age, much of it racked by illness, all of it shadowed by the blindness that began almost with the new century and that, a decade into that century, stopped her painting altogether. Even so, almost to the day of her death, Mary Cassatt received visitors, glad to have among them younger American artists and writers, and she voiced strong opinions on everything from the weather to her own art and life, carrying on like a natural force—which, to be sure, she always had been.

That same power of the aging may be seen in the face and form of the sitter here. Composed and at ease, she sits facing the painter, one arm resting on the relatively high back of the chair. The small bonnet seems almost too small to bear the large pink rose with which it is adorned, a symbol of youth worn by a cheerful embodiment of age.

In her many portraits, it is relatively rare for Mary Cassatt to pose the sitter looking straight "into the camera," as she does here. Generally, the subject is painted looking at something or someone else: a moment observed from outside rather than a direct encounter between the painter and the person painted. Even in her self-portraits, Cassatt more often than not achieves the same effect of seeming to catch herself unaware that she is being caught.

In some ways a contradiction of conventional portraiture, this sidelong approach fits in with Mary Cassatt's whole endeavor: to paint life as it was lived around her—and by her—and not as if posed to be painted for the occasion.

Oil, 28⅝ × 23¾"

Chester Dale Collection
The National Gallery of Art, Washington, D. C.

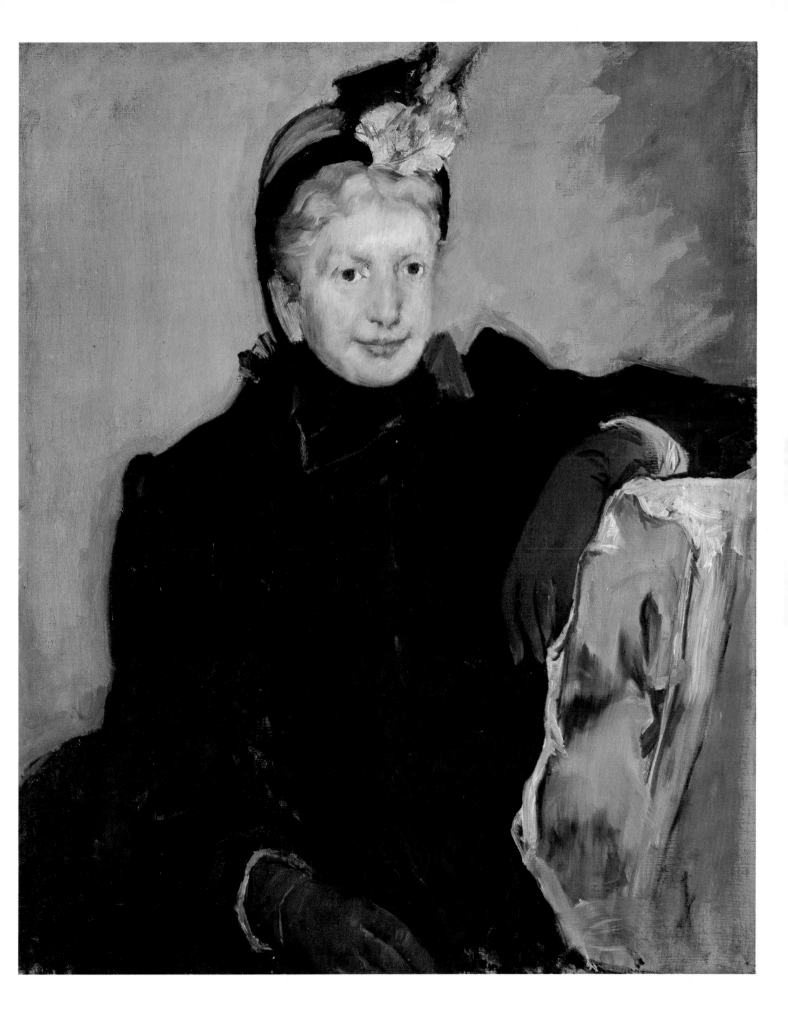

Mother's Goodnight Kiss

1888

THIS IS THE EARLIEST PAINTING bought from the artist by Mrs. Potter Palmer, the Chicago collector, cultural organizer, and general hurricane of the arts in and around the great midwestern city. Typically, Cassatt had first promoted the sale of a Degas to this new collector. Mrs. Palmer was chiefly responsible, a few years later, for the one major mural commission of Cassatt's career—for the Columbian Exposition held in Chicago in 1893.

Mother's Goodnight Kiss exhibits Cassatt's pastel technique at its most felicitous. In places—thanks to the experiments of Degas, faithfully passed on to his American colleague—the color seems like oil paint; elsewhere like crayon, even chalk.

The good-night kiss is affectionate but a trifle perfunctory, a ritual farewell at the end of the day. The little girl is already at least half asleep, though with her eyes still open. The arms and hands of the mother and child form a kind of interlocking composition, and the two are gently but firmly framed by the softly severe geometry of the background.

Pastel, 33 × 29"

Potter Palmer Collection
The Art Institute of Chicago

66

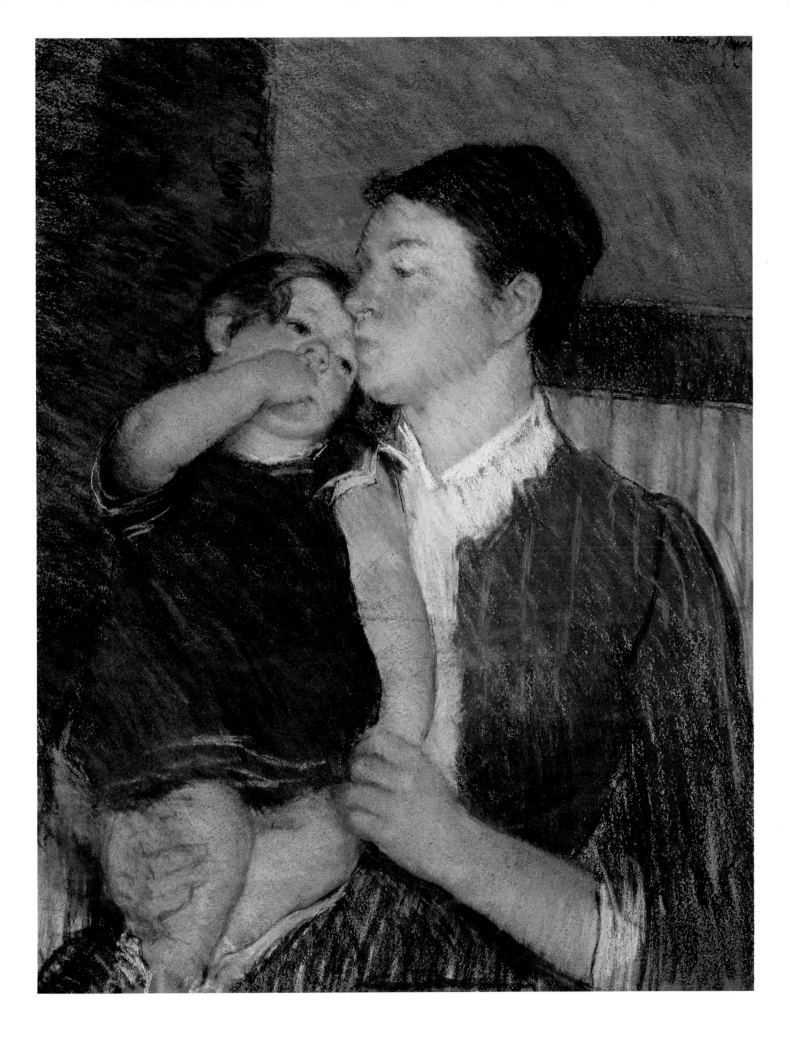

Baby in Dark Blue Suit

1889

THIS PAINTING ILLUSTRATES one of several approaches to a subject that might well be called "Interior with Figures." Two watercolor studies of the same subject exist: the first merely places the fundamental form of the two sitters in the space of the paper; the second places that form within the room, but it is surrounded by the room, almost immersed in it.

Here Cassatt has moved her point of view in toward the two subjects. Now it is they who dominate the interior space, although that space is by no means gone. It is compressed, condensed into what immediately surrounds mother and child. The two figures achieve a kind of monumentality, the greater bulk of the mother set off by the diffuse dove-gray dress she is wearing, in contrast to the concentrated dark blue of the child's suit. The position of his left arm closely duplicates the position of hers—though his rests, hers holds. His vacant expression and limp right arm suggest a child not yet entirely awake or one on his way to sleep.

Those background elements, more or less scattered in the second watercolor study, are here distilled into the effectively contrasting background color areas of the rose chintz behind the mother and the glowing blue and white behind the baby.

Oil, 29 × 23½"

John J. Emery Endowment
Cincinnati Art Museum, Cincinnati, Ohio

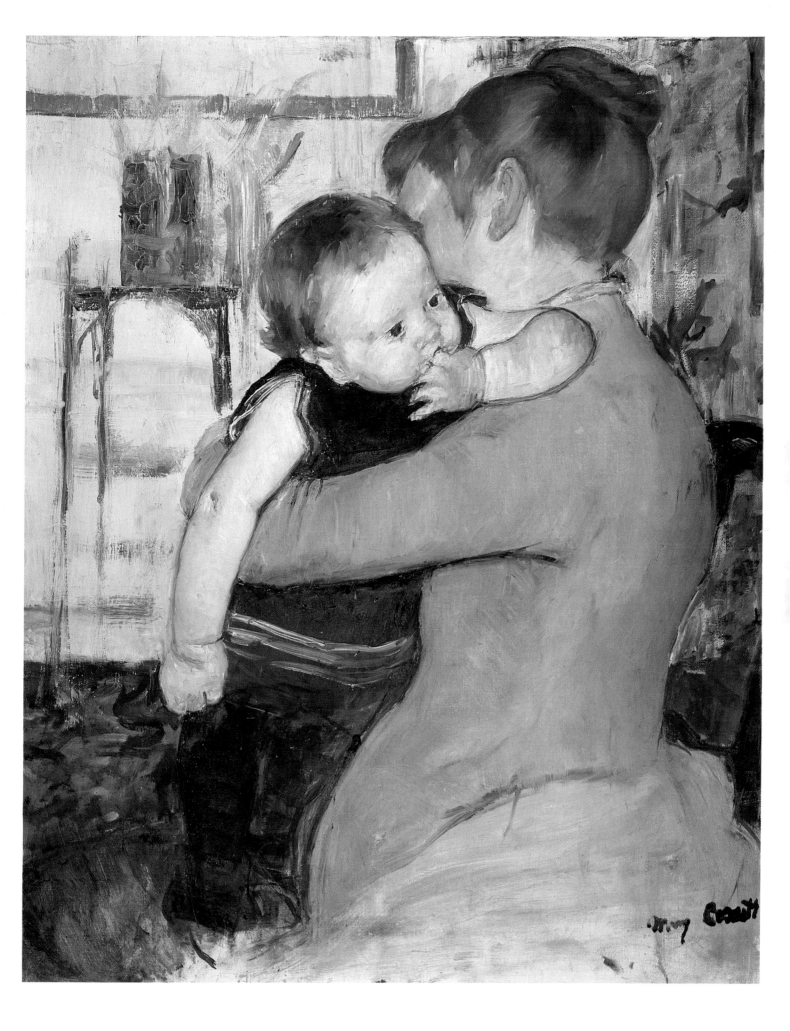

Emmie and Her Child

1889

THE FRENCH TITLE FOR THIS PICTURE, *Maternité*, expresses what a lot of people have thought of it: the summation of motherhood, quiet caring, sheltering love, undivided attention. The quietness is made quieter still by the colors. There is a lot of white, but it never flashes or dazzles. It's all grayed down, or blued down, or browned down— even softened by roses on the mother's dress, as the floral pattern exudes its dominant tone into the surrounding white, an effect of the eye, not of the fabric, and one essential to Impressionist vision. The brightest of the whites is right where it should be, on the baby's chest, to center our attention on the face by reflecting, softly, a little light up there.

The idea of motherhood is expressed here most intently by the utter relaxation of the infant. The child has total confidence in its situation, a confidence beyond feeling confident. Life simply is and is as it should be. The child's hand on its mother's chin is not so much a conscious gesture of love as it is just keeping in touch with the best part of a familiar and totally supportive environment.

For all that relaxation, however, the mother and child are fixed in the painting by the pitcher, which matches the line of the mother's head and shoulder, and by the basin at the child's head. The structure of the painting, beneath its glowing softness, is as firm as the two-handed grasp with which the mother holds the child. The diagonal of the rose-strewn dress is equalled and answered by the opposite diagonal of the shadowed skirt and the lighter upper right background. Like the crockery and the line of the table or counter behind the figures, this centers everything on the two faces and what they say in silence.

Oil, 35⅛ × 25⅛"

The Roland P. Murdoch Collection
Wichita Art Museum, Wichita, Kansas

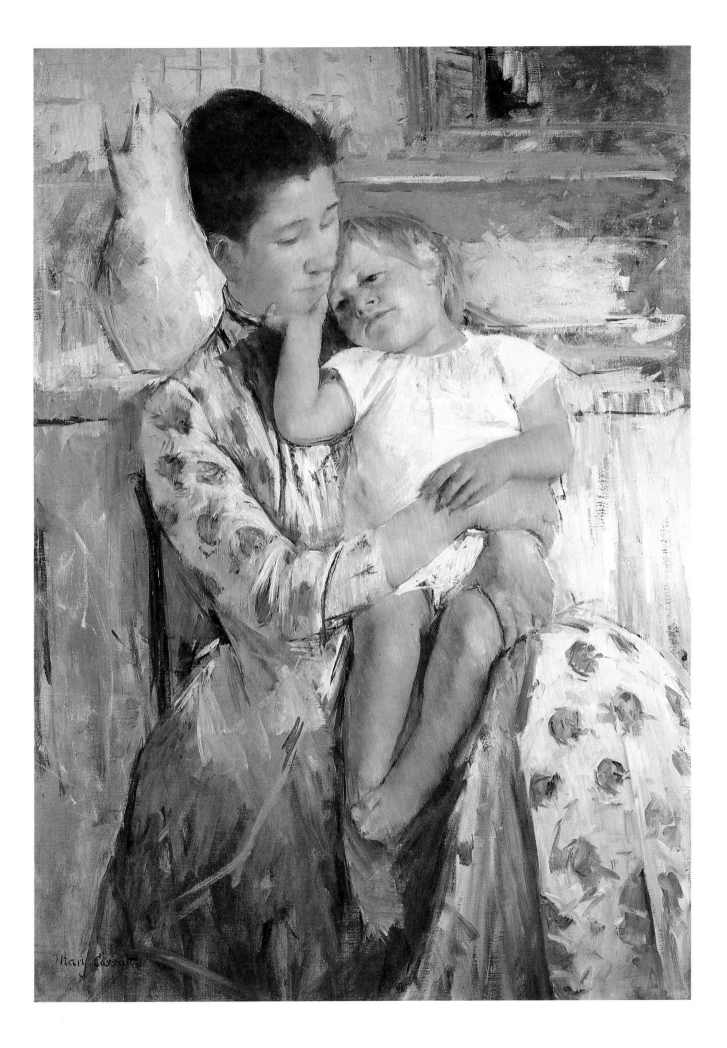

Young Woman Sewing

1890

Mary Cassatt was very interested in hats. Her style of dress was on the whole restrained, even austere, but hats were her one indulgence. She also found them fascinating to paint: a whole gallery of late Victorian millinery could be assembled from her paintings.

The poke bonnet worn by the model here was a survival from simpler times. It was one of the less fanciful headpieces to be encountered in the fashionable Paris of Cassatt's day.

The focal center of the painting is exactly where it ought to be, on those busy, well-trained fingers going about a piece of work that they are quite competent to do but that nevertheless demands the attention it is getting. Perhaps Cassatt saw in this quiet domestic act an analogy to her own use of her hands to create something new out of cloth, the linen of her canvas.

At any rate, the arms and the head, emphasized by the tilted brim of the poke bonnet, both converge toward those working fingers, and the fingers themselves are the most sharply painted details in the painting. Those of the right hand especially express the small, steady motions of the act of sewing. Moving away from this intently seen central act, the picture diffuses into the complementary and contrasting greens of bonnet and dress, lawn and foliage.

Oil, 24 × 19¾"

Charles H. S. and Mary F. S. Worcester Collection
The Art Institute of Chicago, Chicago, Illinois

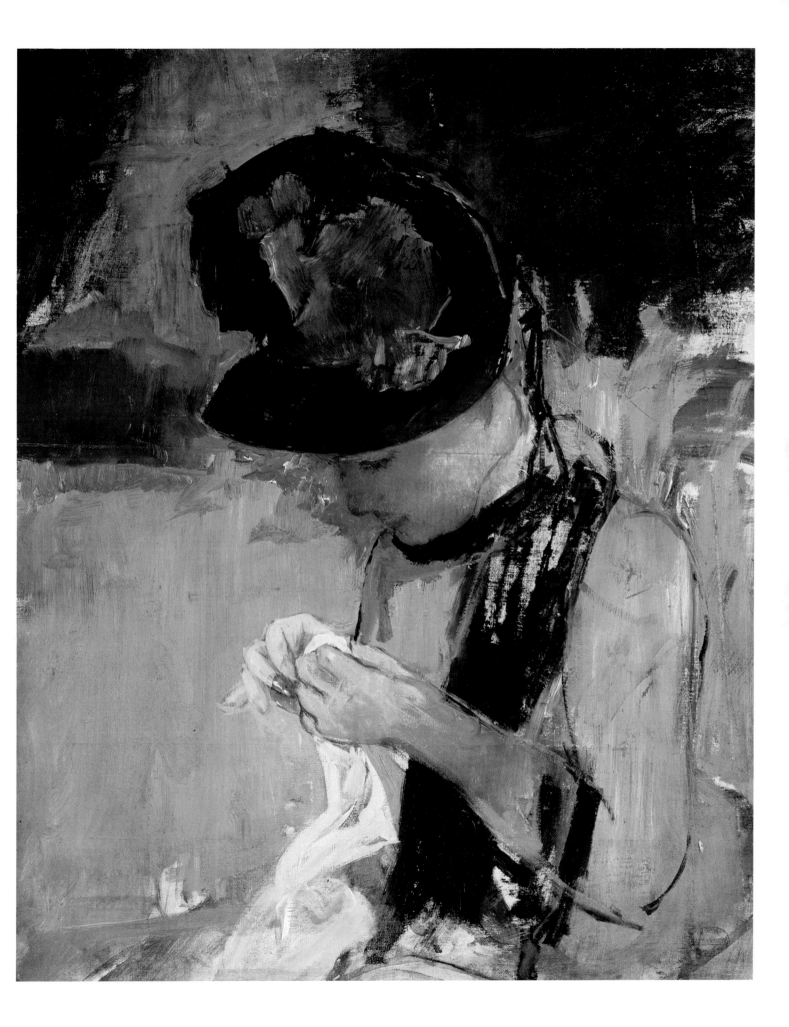

Baby's First Caress

1891

In the normal course of events, this glowing pastel would have found its way to The Metropolitan Museum of Art as part of the formidable Havemeyer bequest from Mary Cassatt's longtime friend, purchaser, and student of European painting. Mrs. Havemeyer, however, left it to her daughter, Mrs. J. Watson Webb, from whose collection it found its way to perhaps the most interesting small museum collection of American art in the country.

There is a nice, easy symmetry in the gestures of mother and child. The baby boy reaches up to his mother's chin, cupping it in his tiny hand, while she reaches down and does precisely the same thing with his left foot. Her right arm, invisible, is parallel to his, supporting his body and just meeting his fingers.

Pastel is very important in the work of Mary Cassatt, as in that of Degas, her friend and mentor. The first really prominent artist to use pastel was also a woman, Rosalba Carriera, during the first half of the eighteenth century. For Carriera, as for other eighteenth- and early nineteenth-century artists, pastel was a way to paint with full color on the full surface without having to wait for drying to see the final effect. Pastel is a kind of chalk, and of all the means of painting it has the least "medium" carrying the color.

Degas eliminated most of the white addition that earlier pastel artists favored, used pastel in strong, pure colors and, again in contrast to earlier artists, allowed his individual strokes to be part of the final composition, instead of blurring them into the overall effect in a kind of imitation of light oil painting, which pastel can achieve quite easily.

Cassatt followed Degas, naturally, but she also combined the Degas technique with survivals of earlier artists, as she did here. The heads of both mother and child could, at first glance, have been painted in oil, but the mother's dress and the entire background could only have been done in pastel.

Pastel, 30 × 24"

Harriet Russell Stanley Fund
New Britain Museum of American Art, New Britain, Connecticut

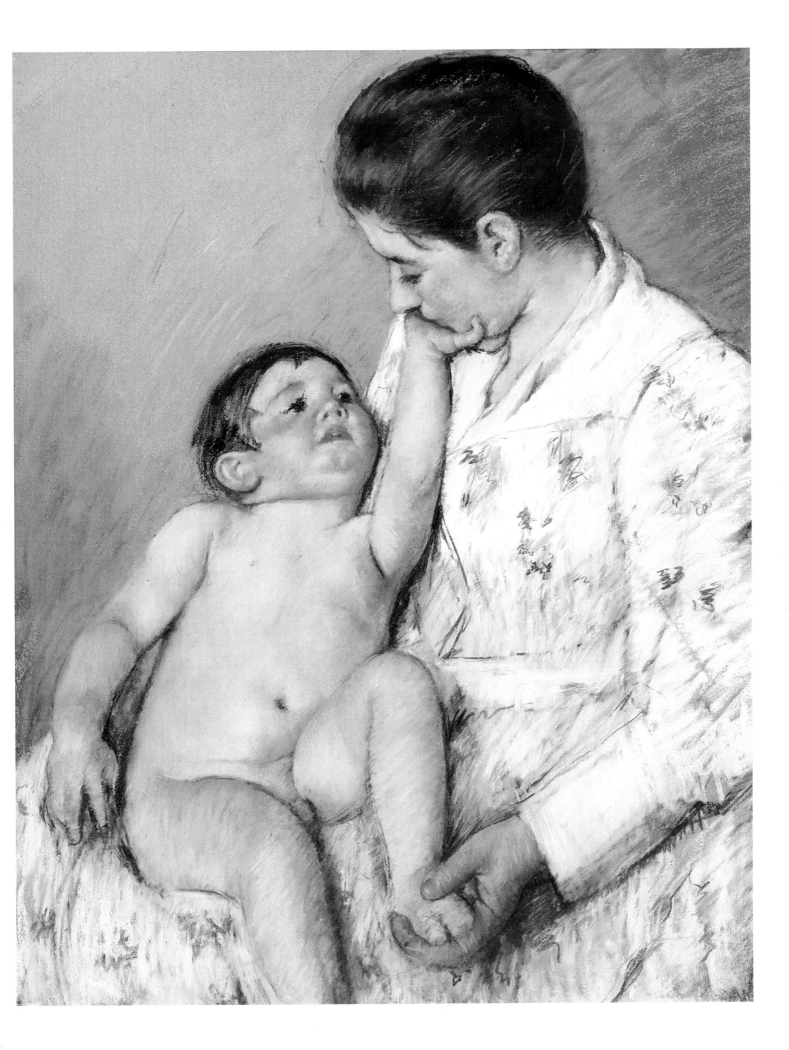

The Bath

1891

MARY CASSATT'S BRILLIANT SERIES of color prints of 1891, usually called The Ten, was inspired by the 1890 exhibition of Japanese woodblock prints in Paris. The effects of that show were immense, ranging from the sudden appearance of Japanese motifs in the work of French artists, to the vogue for kimonos and painted fans, to the Gilbert and Sullivan operetta *The Mikado*, to (three-quarters of a century later) the first act of the Harold Prince-Stephen Sondheim musical *Pacific Overtures*. Mary Cassatt was among the very first artists to be affected. Struck by the simplicity, the boldness, the rich starkness of the woodblocks, she set out to translate their effects into prints of her own. Since the woodblock technique was foreign to her, she made her prints on copper plate and put together an extremely complicated process to achieve her effects. The series deservedly occupies a special place in the history of printmaking.

In 1891, the newly founded *Société des Peintres-Graveurs Français* made itself known by announcing a large exhibition of the work of its members. The *Société*, however, used a strict construction of the word *Français* in its title. Living and working in France was not enough; to qualify, an artist had to have been born in France. This excluded Cassatt, of course, and also Camille Pissarro, her fellow Impressionist, in some ways the most impressionistic of them all. Cassatt was doubly furious: first, because she was excluded from a group largely composed of artists she had joined in opposing the strictures and methods of the Salon; second, because the idea of regulating art by nationality was deeply repugnant to a woman who had in effect exiled herself from her native land for the sake of her art.

Cassatt and Pissarro arranged for a double exhibition of their work at Durand-Ruel, right next door to the *Société* artists. The rest is history and may be read in the many of the plates reproduced in this volume.

Color print with drypoint, softground, and aquatint, 12⁹/₁₆ × 9¹³/₁₆"

Chester Dale Collection
The National Gallery of Art, Washington, D. C.

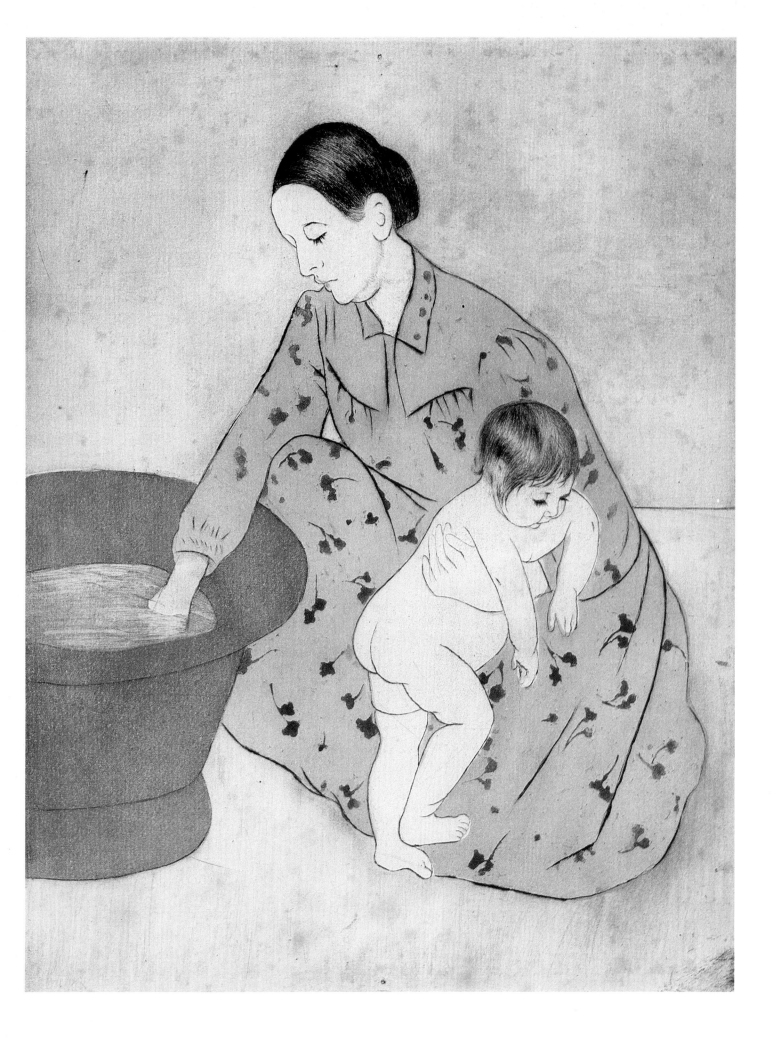

The Lamp

1891

PISSARRO WAS WELL PLEASED with the work of his co-conspirator—or co-counter-conspirator—against the true-blue French *peintres-graveurs* who kept the two of them out of their society and out of their show. He wrote to his son and fellow artist Lucien, "We open Saturday, the same day as the patriots, who, between the two of us, are going to be furious when they discover right next to their own exhibition a show of rare and exquisite works. . . . Miss Cassatt has realized . . . such effects, and admirably: the tone even, subtle, delicate, without stains or seams, adorable blues, fresh rose, etc. . . . the result is admirable, as beautiful as Japanese work, and it's done with printer's ink!"

The ten color prints are indeed as beautiful as Japanese work, and more than one of them shows signs of its origin in the oriental woodblocks. Here, for example, the table and its ornaments, as Adelyn Breeskin points out, "are more Oriental than European." Other Japanese notes turn up throughout the series. Cassatt originally called at least one of the prints "An Imitation of the Japanese." But in spite of that, her achievement is entirely original, a rare blend of the artist's own highly personal vision with a look at first quite foreign to her, and using European print techniques completely different from the woodblocks of the Japanese.

Color print with drypoint, softground, and aquatint, 12⅝ × 10"

The National Gallery of Art, Washington, D. C.

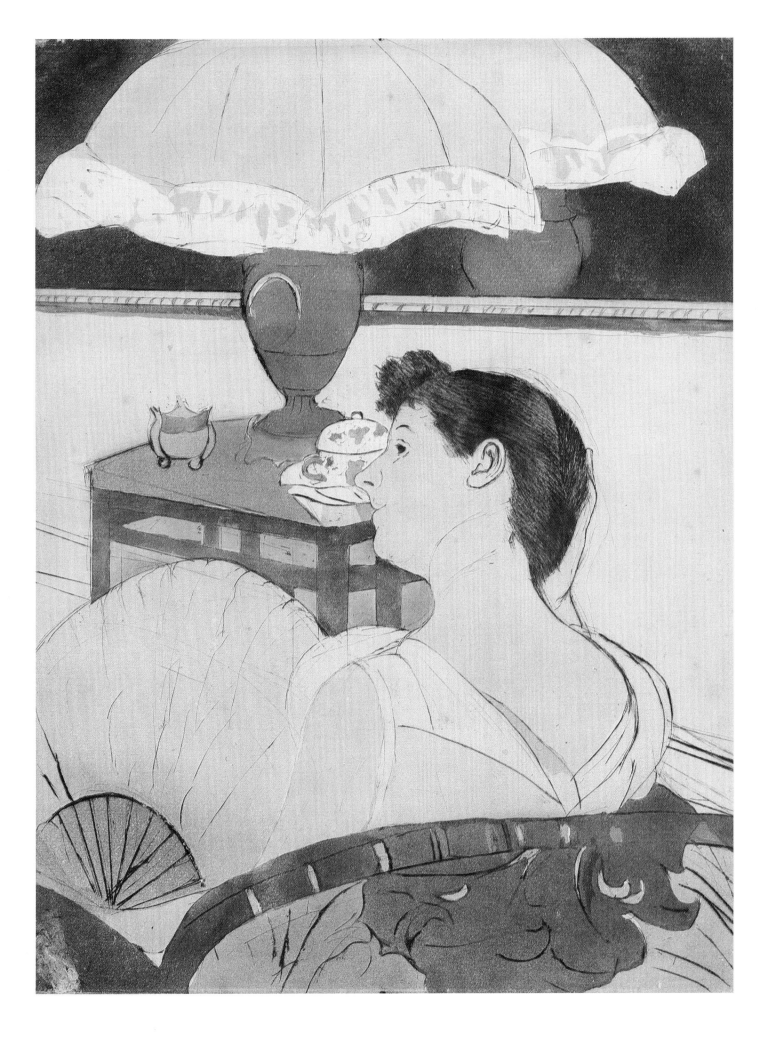

In the Omnibus

1891

THIS PRINT IS REMARKABLE for several reasons. The figure group is, of course, the familiar one of two women and a baby. But one wonders: Are the women a mother and a nurse holding her baby? A mother holding her baby riding with an older friend or relative? Or are we looking at what is simply a chance encounter on a horse-drawn omnibus—that means of public transport explored so thoroughly, decades earlier, by Daumier?

We don't know. But we do know at once that this is a scene never found in Cassatt's paintings and pastels. This is a supremely public place; except for this print, the only public place to be found in the world of Mary Cassatt is the Paris Opera. Even there, we never see the grand foyer or staircase, let alone the lobby, but, inevitably, the private part of that public place, the loge box occupied by a party of a few friends and relatives.

To be sure, even here the women and baby are isolated in semiprivacy. The spare, clean interior is a far cry from Daumier's crowded, sweaty, jostling Paris omnibuses. Still, there was something about the nature of the print medium, as there was not about oil paint or pastel chalk, that got Mary Cassatt for once into a public place.

The composition shows again that she had fully mastered the lessons of Hokusai and the other Japanese printmakers who were the rage of Paris. Space is flattened, and so are the figures in the space. The rectangular divisions of the omnibus might almost be those of the paper walls and lacquered screens of the Japanese, the view of the Seine out the windows a three-leaved screen of a riverside lacking only willow, bamboo, and cranes.

The umbrella held by the older woman, by the way, is the style Mary Cassatt herself used, and she is pictured holding it in several prints by Degas.

Color print with drypoint, softground, and aquatint, 14⁵⁄₁₆ × 10½"

Chester Dale Collection
The National Gallery of Art, Washington, D. C.

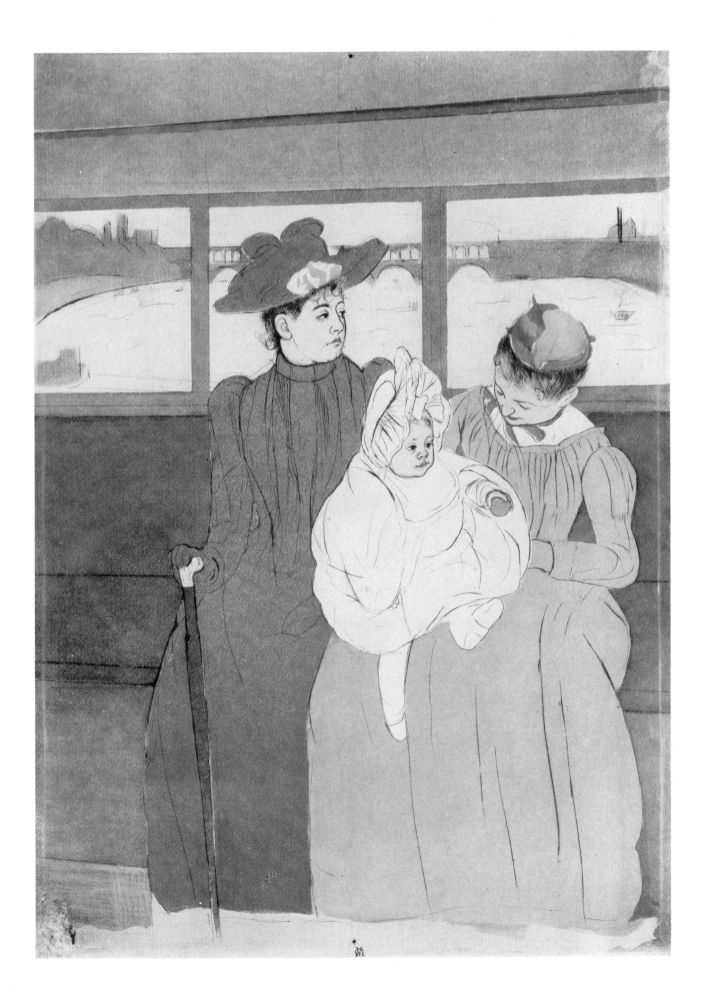

The Letter

1891

Hᴇʀᴇ ɪs ᴀ ᴘʀɪᴠᴀᴛᴇ ᴍᴏᴍᴇɴᴛ of a kind previously seen in eighteenth-century French and Italian paintings, and which would be seen again in the quiet, "intimist" paintings of Mary Cassatt's fellow American artists ten to twenty years later. This is not to suggest that such artists derived their inspiration from Cassatt; it is simply that she first had the idea that women have a life of their own, quite separate from the one they share with men.

The Japanese inspiration for Cassatt's prints is suggested by the slightly crossed eyes of the lady sealing the envelope. It is more evident still in the scattered blossom patterns of her dress and of the wallpaper, and in the curious way the shelf of the desk projects toward the letter writer, its sides not parallel but moving away from each other. As in other Japanese-derived prints in Cassatt's work, there is great compression between the back wall and the plane of the picture itself.

Here, as elsewhere, the Japanese derivation of her prints leads Cassatt toward a two-dimensionality unimaginable in her paintings and pastels.

Color print with drypoint and aquatint, 13⅝ × 8¹⁵⁄₁₆"

Chester Dale Collection
The National Gallery of Art, Washington, D. C.

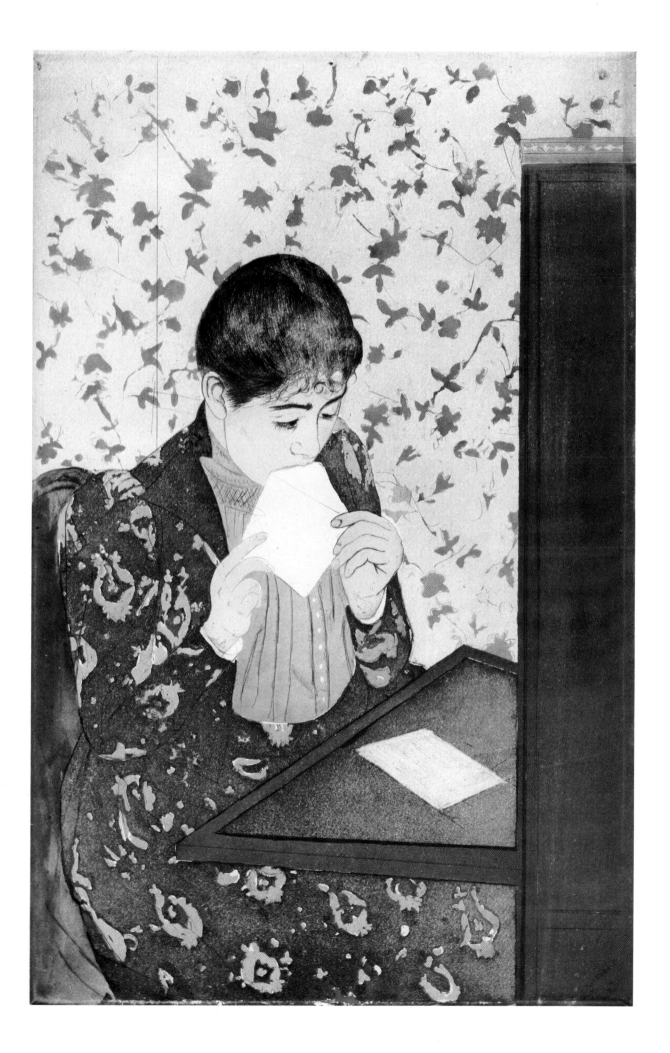

The Fitting

1891

As in *The Coiffure* and *In the Omnibus*, *The Fitting* perceptibly widens our perspective on Mary Cassatt. Specifically like *The Coiffure*, *The Fitting* takes us backstage, into the infrastructure of preparation that supports and is absolutely essential to the Cassatt world of discreetly stylish women visiting, taking tea, conversing quietly, admiring children, and enjoying gardens and the opera.

This world is far removed from that of courtesans, the "floating world" portrayed in the Japanese prints from which Cassatt quite consciously and deliberately took her inspiration. Yet she makes the point that there are similarities. She would not have pushed the point as far as various of her contemporaries did—most notably in the novel—but she was clearly·aware of it and used it.

The Japanese flattening of planes and sharpening of angularities set the frame. The mirrored image, a recurrent motif in Cassatt's work, has never seemed less mirrorlike than it does here. The reflected image seems another person, not just a reflection. The delicate, exquisite limitation of colors translates similar qualities in the Japanese prints into Cassatt's own sensibility. In the browns, grays, and beiges she almost seems to have invented the "greige" later so popular, so basic, in American stocking manufacture. The vertical lines of the dresses of the two women are set off by the squiggly pattern of the paper on the wall, and the floral and leafy one, almost like lily pads, of the carpet.

Color print with drypoint, softground, and aquatint, 14¾ × 10⅛"

Chester Dale Collection
The National Gallery of Art, Washington, D.C.

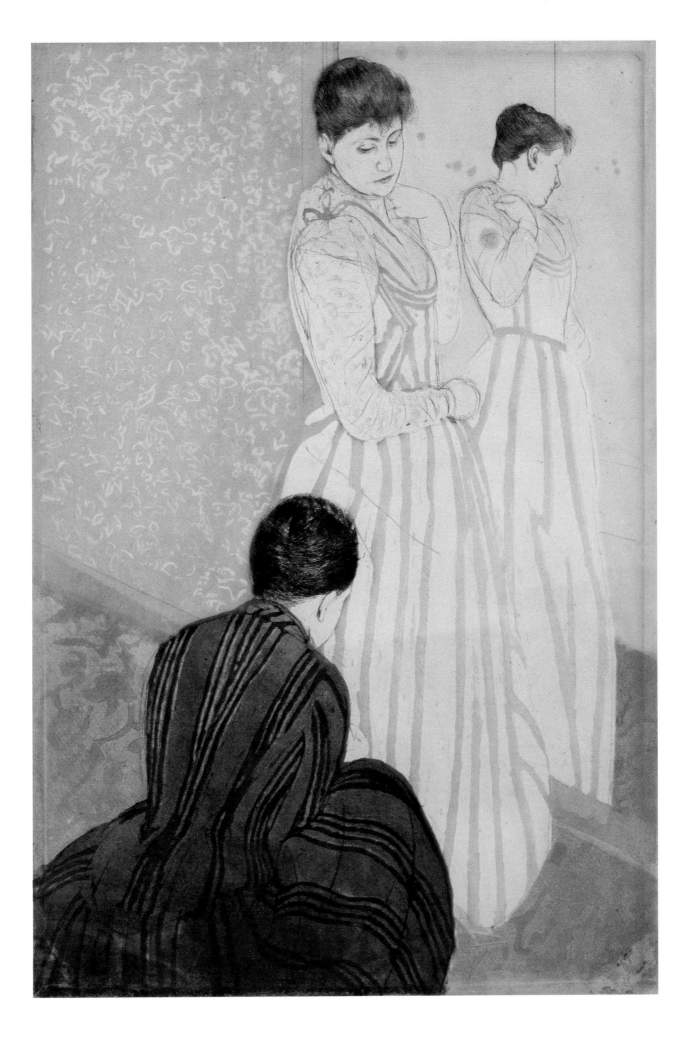

Woman Bathing

1891

ON THE FACE OF IT, it's odd that a friend, admirer, and student of Degas did not paint or draw more nudes than Mary Cassatt did. Degas drew the nude constantly, and the resulting familiarity with the way the body works is evident in all his paintings of ballet dancers, musicians, jockeys, and the rest. Cassatt did not, but whether from a Philadelphia-bred reserve or to spare the feelings of her parents (who had been not at all pleased at her decision to become an artist in the first place) is hard to say. It is worth recalling Philadelphia's accepted opinion of the city's greatest painter: "Tom Eakins is all right, but he is a little hipped on the nude."

That the loss is ours is clear from the two half-nude figures in the ten color prints Cassatt executed for her exhibition at Durand-Ruel. The drawing plays a much more important part in these prints than it usually does in her paintings or pastels, and it is absolutely masterful. Looking at the back of this figure, Degas asked Cassatt, "You modeled the back?" The answer was no. The artist achieved all the feel of the woman's back bending to lean over the washstand solely by the precise placement of the few lines that delineate it. It was in front of this print that Degas paid Cassatt that ultimate, if chauvinist, compliment, "I do not admit that a woman can draw like that."

Colorprint with drypoint and aquatint, 14⁵/₁₆ × 10⁹/₁₆"

Chester Dale Collection
The National Gallery of Art, Washington, D. C.

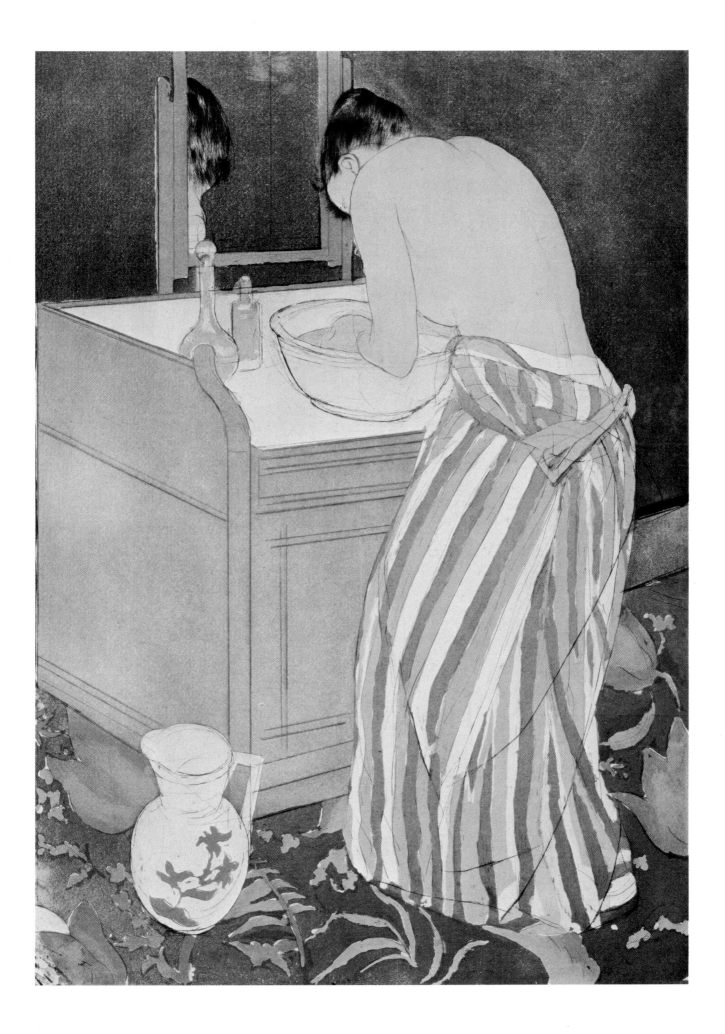

Mother's Kiss

1891

THIS PRINT AND THE FOLLOWING TWO afford us the opportunity to compare typical Cassatt subjects in the print medium as well as in paintings or pastels. The use of line in the prints makes the fundamental difference, though this was actually not necessary. Had she merely wanted to translate her painterly vision into prints, she could have done so much more directly with lithographs. In the year of these ten intaglio prints, color lithography was much in vogue in Paris, thanks to the Japanese woodblock exhibition of 1890 and to Toulouse-Lautrec's translation of those effects. But clearly there was something about copper plate and the things that could be done with it that Cassatt found irresistible.

The French critic and art historian, Claude Roger-Marx said of these ten prints that "together with the sets done by Bonnard, Vuillard, and Toulouse-Lautrec," these "are undoubtedly the most successful color engravings we have." In summing up Cassatt's contribution to printmaking, he wrote, "The term *drypoint* describes not inaptly the remoteness and dignity always preserved by Cassatt, even in her most fashionable or most familiar scenes."

The point is well taken: we can see that remoteness and that dignity even more clearly in these prints than in the paintings, though these qualities characterize all her work and were the saving of Cassatt as an artist. She was, after all, skating on very thin ice in dealing, time after time, with subjects that her contemporary Victorian artists in America and Europe regularly turned into sentimental effusions. It is a defensible position that Mary Cassatt was the greatest artist of mothers and children since Raphael. Both artists achieved greatness by rigorously avoiding the sentimentality that made their subjects so easy of popular acclaim and so treacherous for the serious artist.

Color print with drypoint and aquatint, 13⅝ × 8¹⁵⁄₁₆"

Chester Dale Collection
The National Gallery of Art, Washington, D. C.

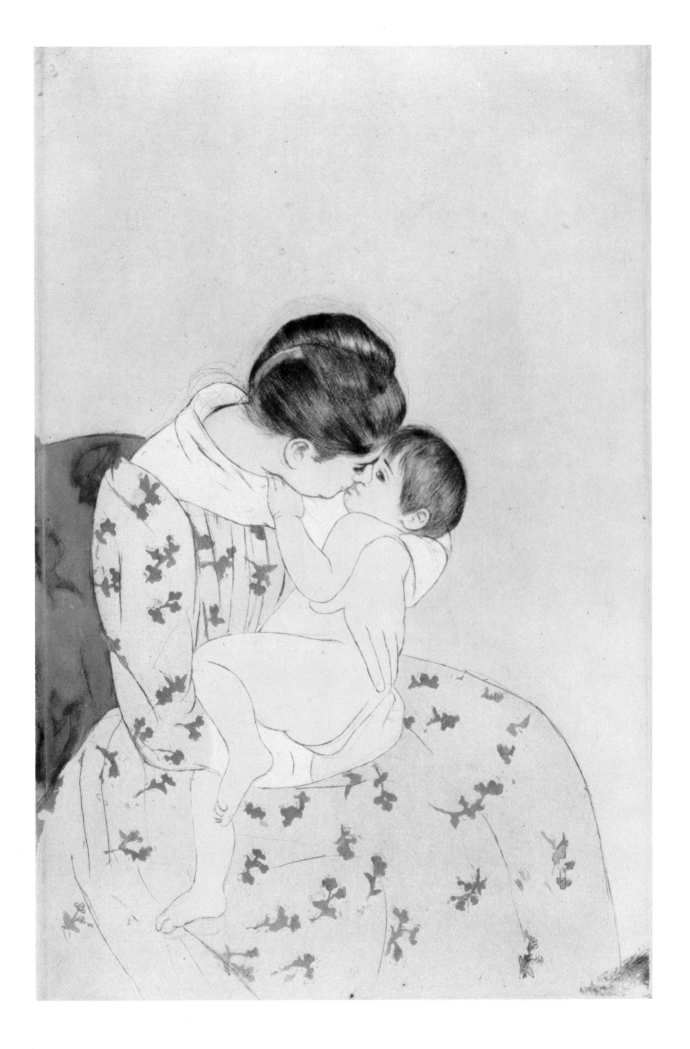

Maternal Caress

1891

Here we have another Cassatt specialty and another triumph over the perils of sentimentality. And it is partially a triumph of craft: the intaglio methods Cassatt combined in this and most of the other ten prints of 1891 are each of them fairly tricky in itself. Etching began as a kind of imitation engraving, the artist covering the copper with an acid-resistant substance, scratching it away for lines and then allowing acid to bite the lines to whatever depth of darkness was desired. Aquatint was devised as a method of imparting grain or tone to large surfaces of an etching, including, if desired, the entire plate. In aquatint, the acid eats a granular pattern through the granular substance on the plate, and the pattern on the plate, when inked, imparts a tonal effect to the printed impression.

Soft ground was also used by Cassatt for color areas, but she used it, too, for line purposes, drawing on a paper held on the coated plate and thus laying bare the plate beneath the drawn lines. She could and did also use such papers for transferring the drawing to the other plates, usually using three plates for each subject. Classical color printing of most kinds employs one plate for each color. By exercising great care in her placement of color, Cassatt could print two colors, perhaps occasionally more, from a single plate. The drypoint, so called because it produces lines in an etching with no use of acid, Cassatt used for that purpose, sometimes apparently drawing directly on the copper plate with the drypoint with no preliminary drawing on paper—an extraordinary feat.

Color print with drypoint, softground, and aquatint, 14½ × 10⁹⁄₁₆″

Gift of Miss Elizabeth Achelis
The National Gallery of Art, Washington, D. C.

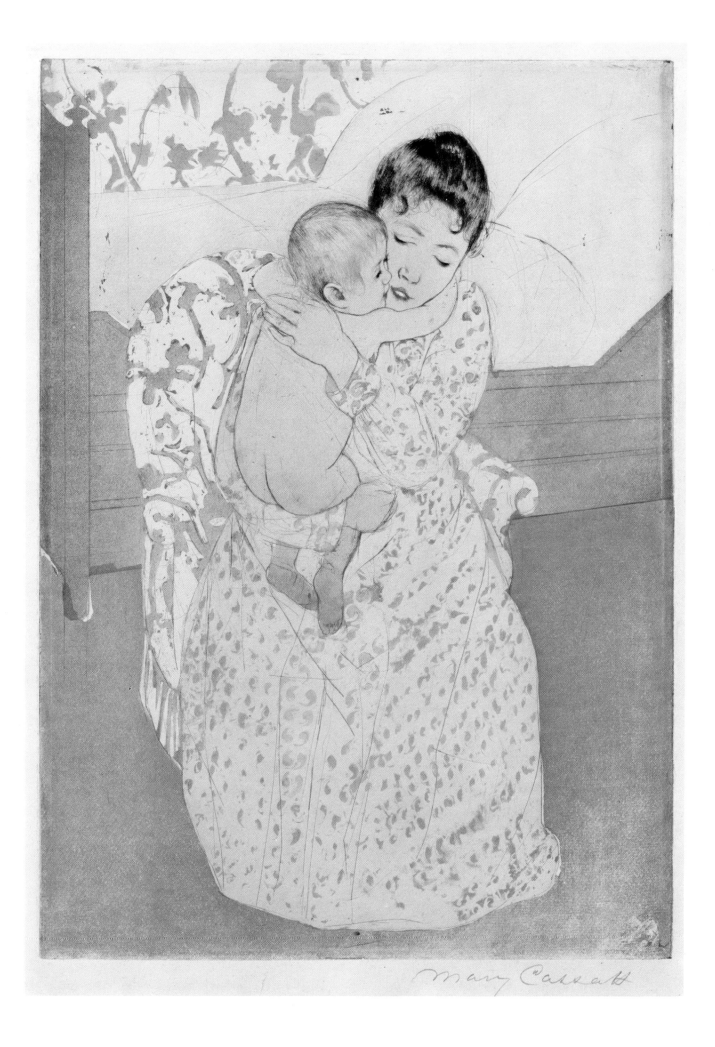

Mary Cassatt

Afternoon Tea Party

1891

HERE IS ONE OF THE QUINTESSENTIAL Mary Cassatt subjects: two ladies of the leisure class taking tea together. She painted it numerous times and in numerous moods: the ladies are worn out from the day and comforted with the tea and warmth and friendship; they are happy to be together, clearly inquiring into each other's current states; they are observing a kind of nineteenth-century domestic ceremony.

Ceremony. That's it here. In this color print, the ceremony of tea comes closest to the tea ceremony of the Japanese. That ritual aspect is clearest, perhaps, in the offering and acceptance of the little cakes or biscuits, but it is present, too, in the flattening of the planes, in the disposition of the tea service—significantly ceramic instead of the silver usually employed in Cassatt's paintings. There is an apparent formality of aspect and gesture here that is quite different from the informality of those tea-takings in the paintings.

Similarly, we have seen that glass screen in the left background before. It appears in several paintings and was evidently both prop and furnishing in the artist's various apartments and villas. But here it takes on a quite new and different look. It seems smaller, more subordinate, somehow, to the two women, more integrated with the rigorous design of the composition.

Surprisingly, when you consider the light-years of distance between the two in subject matter and in attitude, this decorous, typically Cassatt subject suggests in its print incarnation Toulouse-Lautrec, of all people. The deliberately decadent French aristocrat found in the Japanese prints the dissoluteness he chose to live with; the more rigid American aristocrat found instead the ceremony and ritual of her own life.

Color print with drypoint and aquatint, 13⅝ × 10⁹⁄₁₆"

Chester Dale Collection
The National Gallery of Art, Washington, D. C.

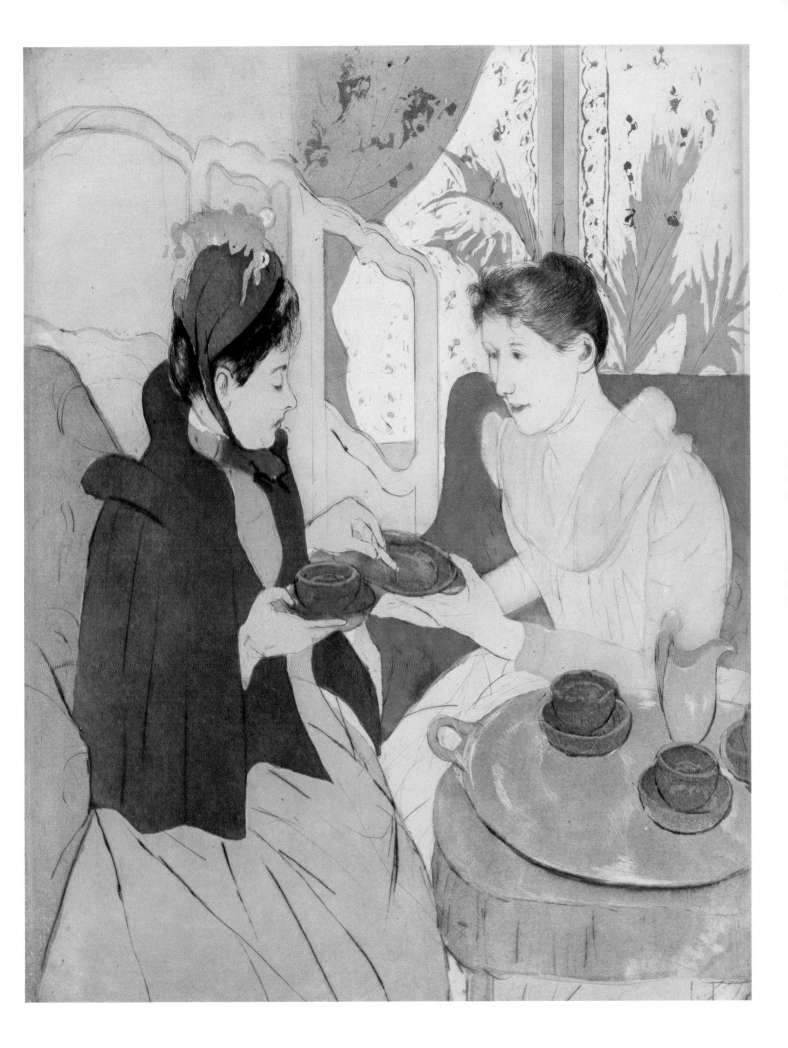

The Coiffure

1891

THIS IS THE OTHER DRAPED NUDE from the ten color prints of 1891. If the handling of the nude torso is not as spectacular as it is in *Woman Bathing*, the use of the mirror, a familiar device for Mary Cassatt, is much more spectacular than it is in *Fitting*. Like both those prints, *The Coiffure* takes us behind the scenes of a woman's life, an area rarely of interest to Cassatt in painting—one probably opened up to her by her intense study of the Japanese woodblocks which preceded her own venture of 1891.

In contrast to the mirror's use in *The Fitting*, where in effect the model and her reflection stand side by side—an arrangement with an extra, private dimension for the printmaker, who always works with such reversed images even without a mirror—here the mirror allows an entirely different angle of view of the model. We see her once from the side and rear, and once in the mirror, straight on. In both images the line is as absolute as in *Woman Bathing*. In Japanese style as adapted by the artist, the floral patterns of the carpet, the wallpaper, and the boudoir chair function twice: both as surfaces themselves and as elements in the flat surface of the print itself. In the mirror those patterns of the chair and the wallpaper float freely to suggest the magic that children see in mirrors.

Cassatt made twenty-five impressions of each of the ten prints. They were an instant success with her colleagues in the Paris art world, less so among the general art public, still less when Durand-Ruel exhibited them in New York. What hurt Cassatt most about the New York show was that none of her Philadelphia family made the trip to see them. Some years later, Cassatt wrote a detailed account of her methods for the use of American printmakers who might wish to try them. So far as is known, no one has.

Color print with drypoint, softground, and aquatint, 14⅜ × 10½"

Chester Dale Collection
The National Gallery of Art, Washington, D. C.

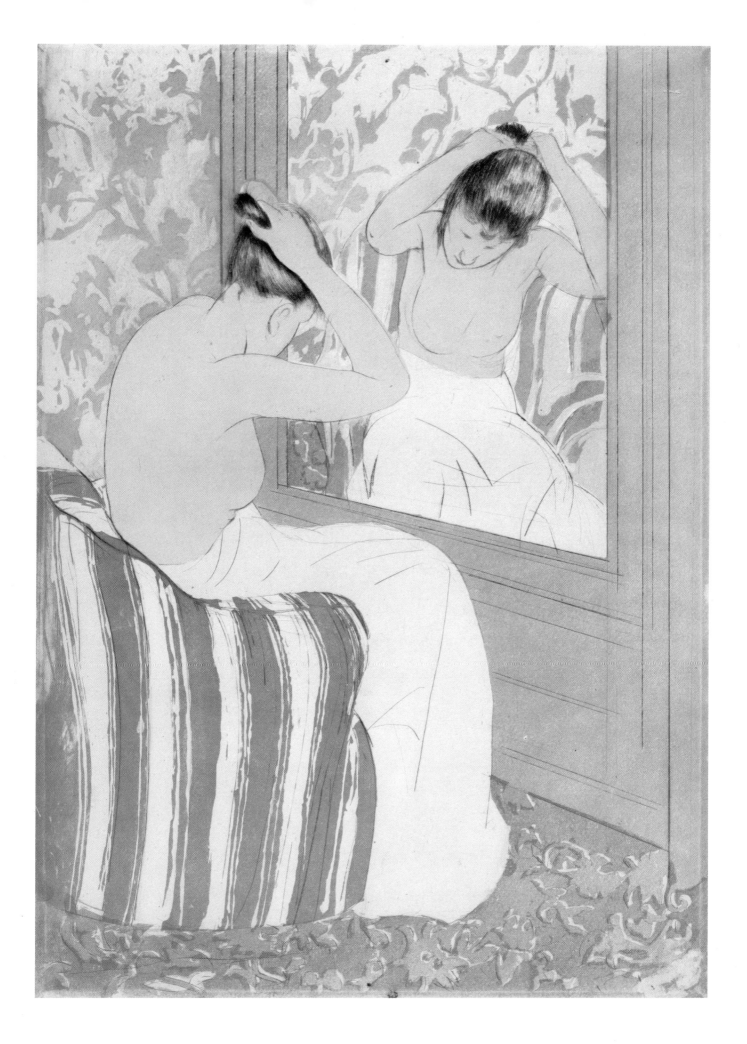

Woman with a Red Zinnia

1891

THE SUBJECT, a young man or a young woman holding a single blossom, is a standard one in Renaissance painting. Mary Cassatt's treatment of the theme is very different.

The Renaissance paintings, in the first place, almost always used the flower for its symbolic meanings: the virtues the various blooms were said to stand for, the dedications represented by the subject's holding them, even a play on the sitter's name. Secondly, Renaissance painters almost always placed both the sitter and the flower in profile, with the flower close to the face, both profiled face and profiled flower set dramatically in isolation against a flawless blue sky.

Here, Cassatt uses an almost full-front face, but not quite—she almost never did. Balancing the slight turn of both body and head away from the picture plane toward the right, the young woman's glance at the zinnia is toward the left. The red of the flower gathers in, intensifies, the auburn of her hair.

Meanwhile, behind the young woman is one of the rare Cassatt treatments of an extensive piece of landscape. The girl's head is, in fact, centered on a sort of sketch, or outline, for the classical centering device of the avenue, or *allée*, of bordering trees. But the trees are too young and too irregularly placed to be more than a sketch. And, at the end of this putative *allée*, the visual concentration, instead of stopping, goes off to the right, following the sunlight and on deeper into space, with older trees at the edge of a forest punctuating sunlit lawn with shadow. It is a remarkable landscape for an artist who saw landscape only as the background for figures.

The dress worn by the young woman is also a remarkable piece of painting—as it was, of course, a remarkable piece of dressmaking. All its elaboration is recorded—the braid along the borders, the full-length pleats with the belt beneath, diagonal stripes underlying the vertical pleats—yet it does not command any of the attention reserved for the young woman herself. The focus is sharpest where it belongs, on the face and hands of the woman holding the zinnia and on that flower.

Oil, 28¾ × 23¾"

Chester Dale Collection
The National Gallery of Art, Washington, D. C.

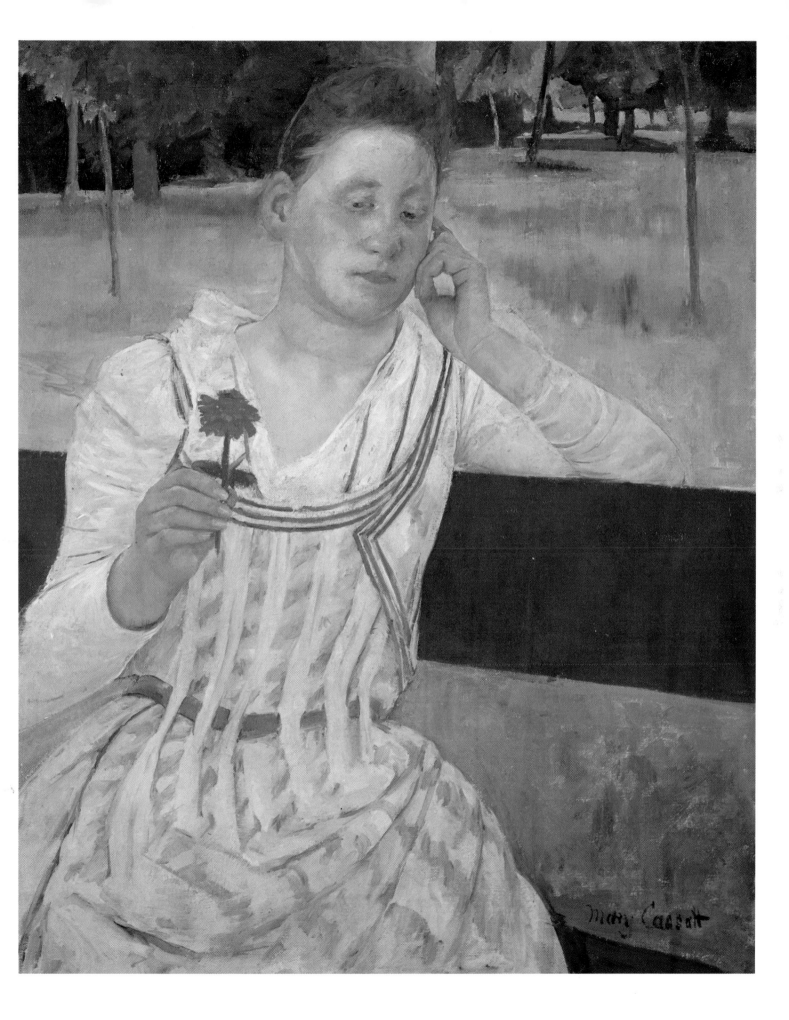

Young Woman Picking Fruit

1891

THIS PAINTING IS ALMOST A PRECURSOR for what ought to have been, and up to a point actually was, the most important of the few public commissions Mary Cassatt received. Given the highly personal nature of her vision and given, too, the general state of art consciousness among American public officials (or any others, including French) during her lifetime, it is amazing that she received any such commissions at all. She started a project for the State Capitol at Harrisburg in her native Pennsylvania, but withdrew when she found the whole enterprise riddled with graft, hardly a surprise to anyone familiar with Pennsylvania politics of the period. For the commission in question, however, Mary Cassatt was involved on several levels.

In the first place, her contact and the person responsible for the commission was Mrs. Potter Palmer, Chicago's great art patron and a friend and customer of Cassatt's. Then, too, the occasion was the World's Columbian Exposition, in Chicago, celebrating the four-hundredth anniversary of the discovery of America, a transatlantic occasion of special interest to Cassatt as an American in Paris. Finally, the mural, by far the largest work she ever painted—fifty feet across and twelve feet high—was for the Woman's Building, a project planned and executed by women, celebrating their contributions to civilization and the arts. As a fervent believer in women's rights, Cassatt was delighted to participate.

The central motif of the mural was a scene of women picking fruit, not like this but obviously derived from Cassatt's interest in the subject at the time of the commission.

In this picture, painted the year before the commission, the artist has backed away from her familiar style with floral prints. The flowers on the dress of the seated woman seem exactly what they are, flowers of fabric and nothing more, in contrast to Cassatt's more customary blurring of the distinctions among printed or embroidered flowers, real flowers, and real strokes and splashes of paint.

The Chicago mural, after being extensively reproduced and described and, of course, seen by thousands at the Exposition, simply disappeared when the show closed, and no one has ever reported seeing it since. The huge mural, complete with decorative painted borders, was painted at the artist's country place, Bachevillers, where she had a large glass-roofed studio built especially for the project, including a trench in the ground into which the painting could be lowered when she was painting the top parts.

Oil, 52 × 36"

Museum of Art, Carnegie Institute, Pittsburgh, Pennsylvania

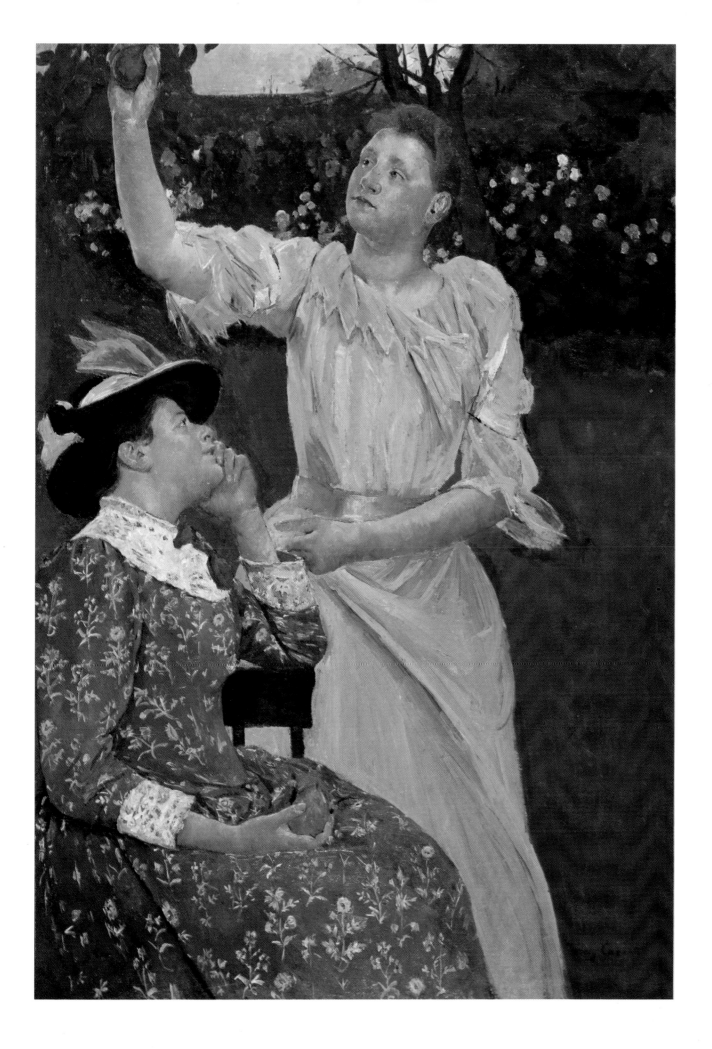

The Bath

1892

THIS IS ONE OF MARY CASSATT'S universally recognized masterworks, a stunning combination of compositional monumentality, her own woman and girl *intimism*, borrowings, or "learnings," from both Degas and the Japanese made thoroughly her own, and, finally, just superb painting in every fold of cloth, every light on flesh.

The broad stripes of the dress in pink-lavender, moss-green, and white command the whole center area, at once setting off the little girl's body and standing out from the darker tones of carpet below, wallpaper and painted bureau behind. The right arms of both figures and both the little girl's legs are as straight as the lines in the dress, the left hands of older and younger meet and are alike at the waist of one, the knee of the other. On both sides, there is total absorption in the task, and that total absorption is the hallmark of Mary Cassatt's world of women and children.

The scene is severely cut off around the edges. The figures occupy most of the space available, seem to occupy even more than they do. The planes are tilted toward us so that we are looking down on this event, which is, after all, taking place on the floor. All these notes could be found in the Japanese prints that so delighted artistic Paris in 1890, as could the placing of an object—here the pitcher—at the very frame of the painting so that it seems almost to lean out toward us.

Finally, the picture defines once and for all the difference between those baths by Degas and those by Cassatt. For him the bathers were forms in motion to be caught, miraculously, at point after exact point of surprising gesture, disposition of limbs, stretch of muscles. For Cassatt, bathers were all those things, but they were always human souls communicating with each other and themselves.

Oil, 39 × 26"

The Art Institute of Chicago, Chicago, Illinois

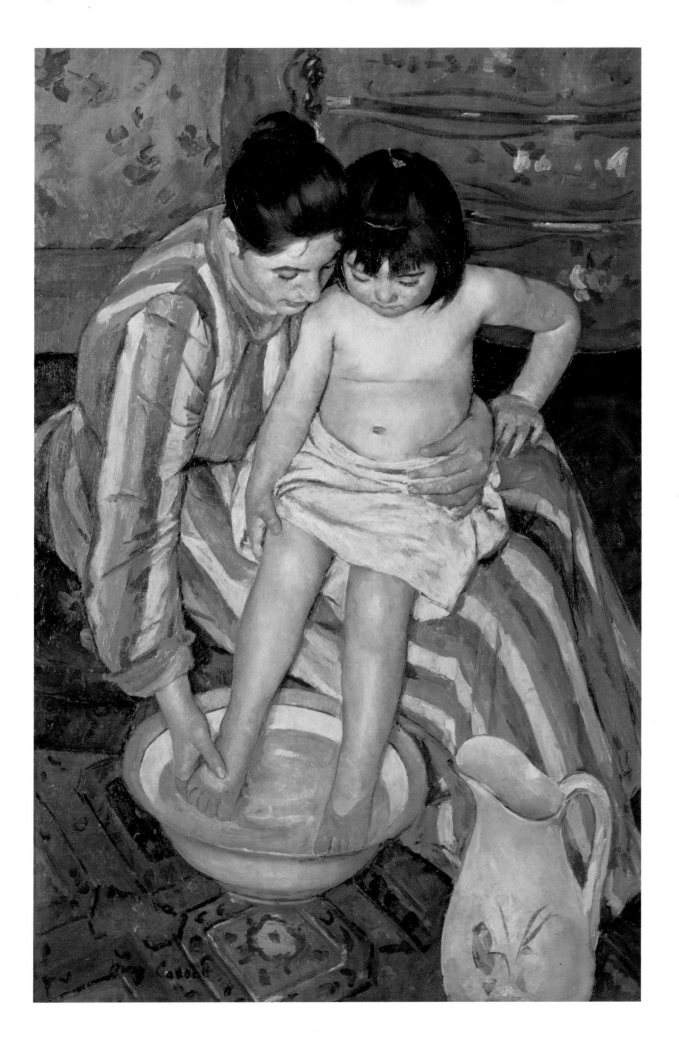

Baby Reaching for an Apple

1893

AN EXTRAORDINARY PAINTING from every point of view, *Baby Reaching for an Apple* is another spin-off from the Columbian Exposition mural of the same year, which was tragically lost. The central panel of the triptych from the large Exposition work was called "Young Women Plucking the Fruits of Knowledge and Science," the kind of title that might have been proposed by any academic on either side of the Atlantic in 1893—or, for that matter, approved wholeheartedly by any committee offering commissions. But the allegorical aspects of such a title were totally ignored in the Cassatt mural, as far as can be judged from photographs of it. Indeed, this strong painting seems to embody a background figure group from that central panel of the mural. As in all of Cassatt's post-student work, these are a real woman and a real baby surrounded very much by real apples hanging there for the picking.

The glowing pink of the woman's dress, her face, and the baby's body contrast sharply with the appropriately apple green that drenches the background. There is a vertical concordance in this vertical composition: the pink of the woman's dress is subtly but perceptibly brighter and hotter at the sleeves and shoulders than in the skirt, exactly corresponding to the same change of values in the background green.

Meanwhile, the painting of the apples is a small miracle all by itself. Globe after globe is separate and distinct from all the others, each is individual, and each defines and occupies the space around it. Taken together, the apples create a kind of archway framing mother and child.

Oil, 39½ × 25¼"

Virginia Museum, Richmond, Virginia

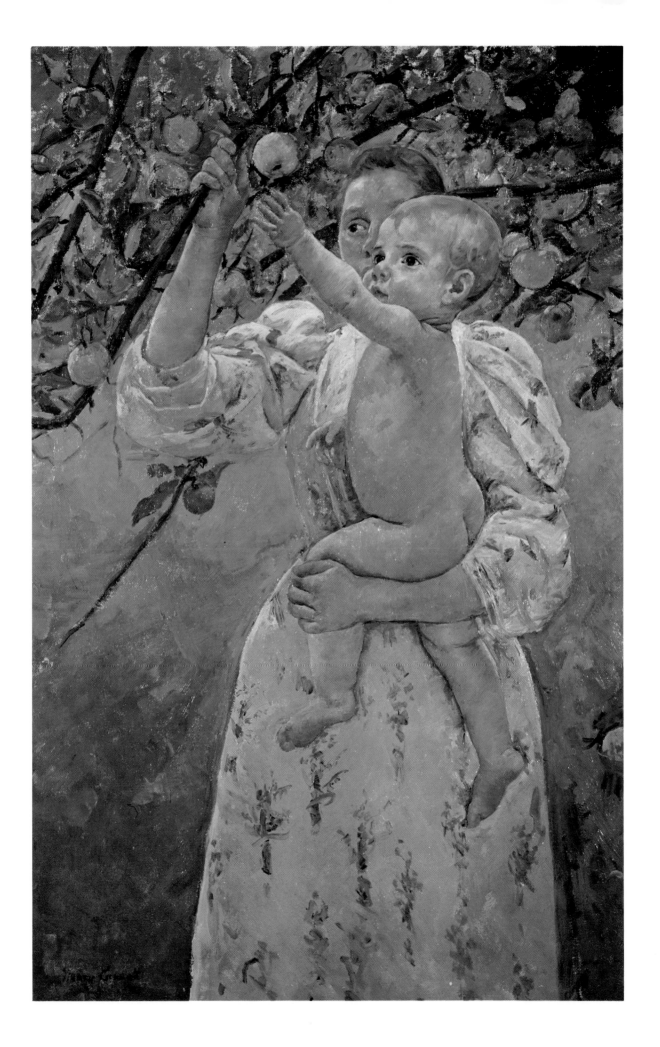

The Boating Party

1893

IN PAINTING *The Boating Party*, Mary Cassatt set out to paint a major work and succeeded magnificently. This is, by far, the most "Japanese" of her paintings—that is, the one most suggestive of the flattening of plane and the simplification of color areas that characterized the Japanese prints which had such a profound effect on many of the Impressionist painters, most notably Manet. Manet had already executed a similar boating picture more than twenty years earlier, and Mary Cassatt not only knew it but had advised her friends the Havemeyers to buy it. It now hangs in The Metropolitan Museum of Art. There can, however, be no question of copying. Manet's picture is the reverse of this, with the focus on the rower, not on the passengers.

The importance Cassatt attached to this work is evident in its size, nearly three feet by four feet. And the subject, of course, is unusual for her. When she moved outdoors at all in her work, it tended to be to the garden or a park. This was a challenging departure, and on what was for her the grand scale.

But to that rare locale on the water Cassatt brought her familiar favorite pair, the mother and child, here linked by the way they watch the boatman, who also looks at them. All the lines converge, from the surface of the painting—where we ourselves seem to be aboard the boat—to that mother and child: the curve of the boat's side and that of the sail, the oar, and the arm of the boatman holding the oar. Incidentally, given the sail's position, it is fair to conclude that the boatman is rowing in the widely used European method, pushing, rather than pulling as American rowers do.

It is perhaps a minor distinction but a distinction nonetheless that *The Boating Party* is one of the most widely reproduced paintings in the world: It served as the subject of a U.S. postage stamp for first-class mail.

Oil, 35½ × 46⅛"

Chester Dale Collection
The National Gallery of Art, Washington, D. C.

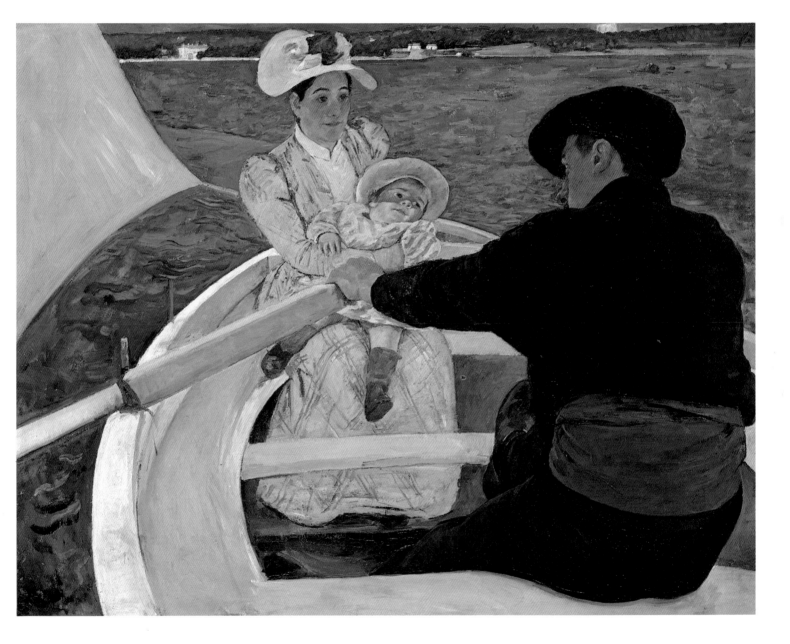

The Banjo Lesson

1894

CASSATT PAINTED A MANDOLIN PLAYER and a lute player in the early 1880s, when she was still teaching herself to paint by copying the Old Masters. Except for those two early ventures, the banjo seems to be the only musical instrument Cassatt used in her art, despite the example of her friend and mentor Degas, who touched in his time upon many of the instruments in the orchestra.

One can only speculate that the relative importance of the banjo was a patriotic matter. Two years before this work, Cassatt had painted her very large mural for the Women's Building at the World's Columbian Exposition in Chicago. In the right-hand section, three women in a meadow are centered on one of their group who sits in the grass and plays a banjo, while one woman dances another sits and listens. In view of the generally patriotic nature of the celebration (America in those days believed that what Columbus discovered was the United States), it seems reasonable to assume that Cassatt quite deliberately chose as her music theme the one distinctively American musical instrument, the banjo. A folk invention of Afro-American slaves in the eighteenth century, possibly derived from the tambourine, it was a favored instrument in the minstrel shows of the nineteenth century and survived to be used in jazz bands in the twentieth.

Pastel, 28 × 22½"

Virginia Museum, Richmond, Virginia

Summertime

1894

SUMMERTIME IS A BOATING PICTURE but it is almost the complete opposite of Cassatt's much better known *Boating Party*. *Boating Party*, painted about a year earlier, has a tightness of composition that is shown in the strain of the oarsman's stroke, the intensity of the glances he exchanges with both passengers, the woman and the baby sprawling on her lap. In contrast, *Summertime* evokes the atmosphere of Gershwin's song of that name, "And the livin' is easy." As for the line, "Fish are jumpin' "—Mary Cassatt wrote of the way she was working that late summer: "I am now painting with my models in the boat, and I sit on the edge of the water, and in these warm, still September days it is lovely; the trout leaping for flies, and when we are still we can see them gliding along. The whole beauty of the place is in the water." She went on, "One of my neighbors who has had a stream and a dam like mine, told me they had fished a trout and when it was opened found a mole in its stomach."

The place is probably Cassatt's newly purchased summer home, Château de Beaufresne, which had a large pond. In this painting the beauty is in the water, which occupies rather more than four-fifths of the space. The livin' could hardly be easier, with the two young girls in their light summer dresses—the toiling rower, invisible beyond the frame—but also in the manner of painting, the composition. All tautness is relaxed. The painter is home from vacationing. The loose composition, the paint strokes, the very ducks on the pond emphasize the decidedly unemphatic theme.

Oil, 28⅞ × 39⅜"

Armand Hammer Foundation, Los Angeles, California

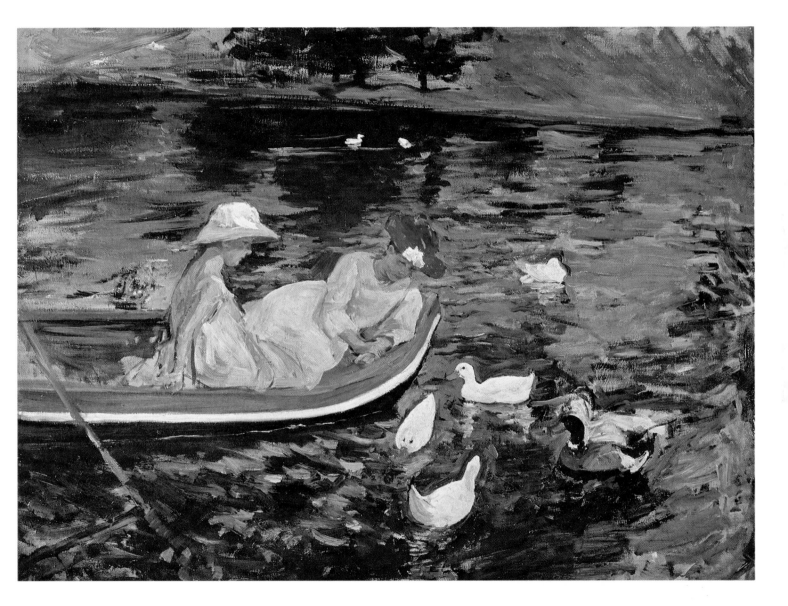

Mother Feeding Her Child

1898

LIKE MANY OF CASSATT'S OTHER PASTELS, this one shows the wonderful effects of flesh and fabric she could achieve with the medium.

The picture depicts a rare mixture of two of Cassatt's worlds: that of ladies taking liquid nourishment of some kind together, and that of mothers and their children. The two naturally come together here because the mother is helping her child to have a drink and at the same time teaching her the essential art of sitting at a table and holding a drinking vessel in one's hand. This is the first step in a process that will stretch over years, and culminate in the scenes Cassatt painted so enchantingly of women entertaining one another, taking tea together.

The child holds the glass, but it is steadied and insured by the mother's hand. Her other hand might seem to be loosely, casually, resting on the chair they both sit on, but it is actually poised, ready to support the child.

As always, the painting of the tableware is exquisite, causing us a faint regret that Cassatt never saw fit to paint pure still lifes for their own sake. Like the landscapes she never painted, the still-life elements, however beautiful, are secondary to her interest in the figure group in an interior. Here the figures, mother in light green, child in yellow with orange accents, are nicely set off by the vibrant, non-specific gray of the background.

Pastel, 25½ × 32"

Gift of Dr. Ernest G. Stillman, 1922
The Metropolitan Museum of Art, New York City

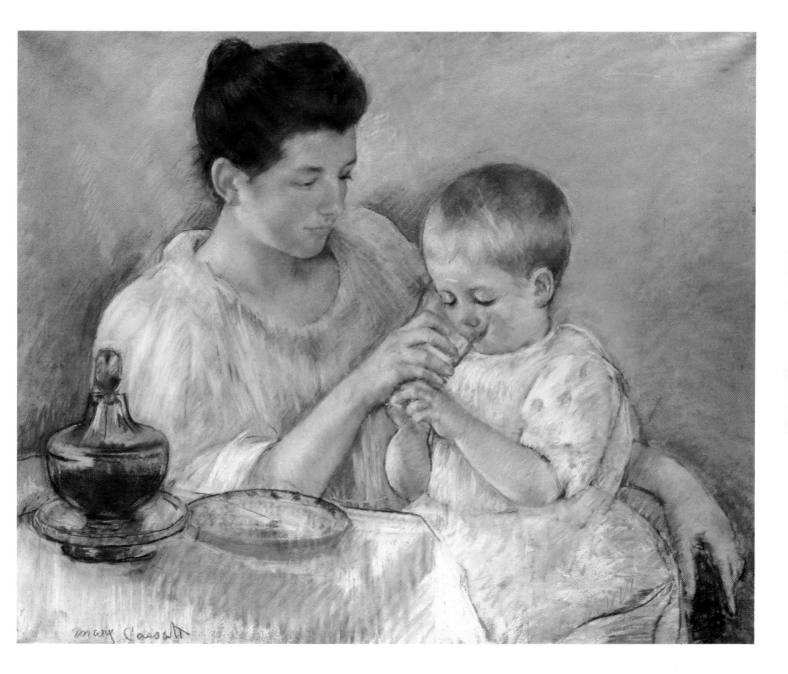

Baby Charles Looking Over His Mother's Shoulder (No. 3)

c. 1900

THE BACK OF SOMEBODY'S HEAD is seldom as interesting to paint as the front. On the other hand, it is an attractive composition to show a baby looking over its mother's shoulder because the pose is typical of babies. Cassatt's solution is classic. She paints Baby Charles in that natural position, incidentally achieving great contrasts between the skin tone of the two, between their hair, in color, texture, and sheer quantity, and between the baby's skin and his mother's bright orange-red gown. But behind the figures, she places a mirror (or, more accurately, in front of the mirror she places the figures). So we are given the baby-over-the-shoulder arrangement without sacrificing the mother's face. We even glimpse the baby seen from the back. This is perhaps Mary Cassatt's most remarkable use of a favorite and recurring device in her work, the mirror.

Typically, the mirror itself is cut off by the upper right corner of the picture, and within the mirror those two edges also cut off the reflection of the mother's face and the back and head of Baby Charles. The real mother-and-child are separated from the reflected mother-and-child by the top of the console under the mirror, effectively reducing the size of the reflected images compared to the real one. All these things create a powerful diagonal thrust that gives the central group a dynamic character it would not have all by itself. It is almost as if the mother and child were attended by their personal double icon. Their own portraits—appropriately reduced in size—seem guardian figures as Charles and his mother present themselves.

Oil, 28 × 20⅞"

Carll H. De Silver Fund
The Brooklyn Museum, Brooklyn, New York

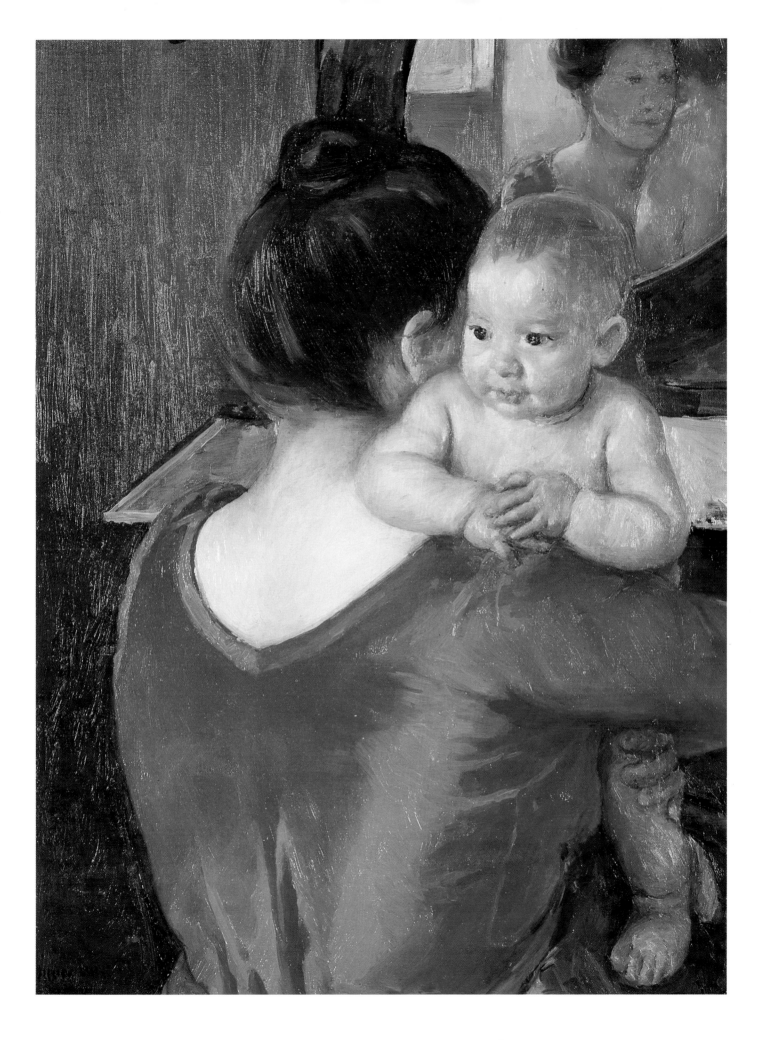

After the Bath

c. 1901

THERE ARE SEVERAL VERSIONS of this trio of mother, daughter, and baby boy, but this one is the culmination of them all. While losing none of the intimacy and charm common to all of the versions, *After the Bath* achieves the monumentality Cassatt attained when working at the top of her form. There is a classic inevitability about the final arrangement of the figures, even suggesting a frieze in the shallow space they occupy, the decidedly horizontal nature of their relationships to one another.

Within that horizontal, friezelike pose, Cassatt has brought the three close together through a loose yet interlocking arrangement of arms, hands, and, for the baby, one foot. The baby and the girl (Sara, a model Cassatt used very often at this time) frame their mother's head with their arms, and Sara's hand clasps the wrist of the baby on the mother's shoulder. With her other arm and hand, Sara rests on her mother's arm and back. The mother duplicates the handclasp of Sara and the baby in her own grasp of the baby's ankle and foot.

Cassatt's command of the pastel medium is evident in every stroke and in the variety of effects—from the smoothness of the baby's body to the coruscations of light on the mother's bodice to the rich warmth of the sun colors in Sara's dress.

Responding to the mother's close interest and to the adoration of his sister, the baby rises up like an infant god from the almost ceremonial bath.

Pastel, 25¾ × 39¼"

Gift from J. H. Wade
Cleveland Museum of Art, Cleveland, Ohio

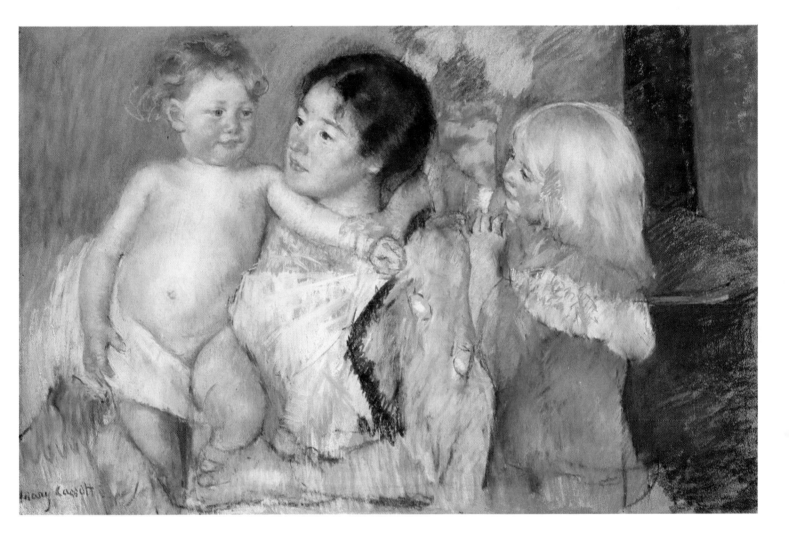

Baby Getting Up from His Nap

1901

THIS PICTURE IS A MARVEL of contrasts between the soft lines of nude baby flesh and feminine garments and the hard lines of furniture. The stepped arrangement of the headboard of the bed and the lower screen are echoed, softly, in the silky round hair and heads of the child and the mother. In front of them, combining aspects of both those contrasting elements, is the oval tray, with its combination of round but hard shapes—the pitcher and sugar bowl, the plate, the fruit in the dish, all round, most hard, but seeming soft compared to those straight lines, unyielding surfaces of the planes behind the two figures.

The still life in the foreground would be a beautiful small picture all by itself. There is a wonderful feeling for silver, for crystal, for fruit, and for the way they all go together.

As often in Cassatt's mother-and-child pictures, both participants go about their own business, the last thing on their minds some sort of sentimental gesture, or even look, at each other. The baby looks off toward the left with brightening interest in something we can't see. The mother looks down at something we can see, namely the baby's feet which, after a bath, need drying.

One of the great virtues of Cassatt's *maternité* paintings is that they are rooted so solidly in reality.

Oil, 36⅛ × 29"

George A. Hearn Fund, 1909
The Metropolitan Museum of Art, New York City

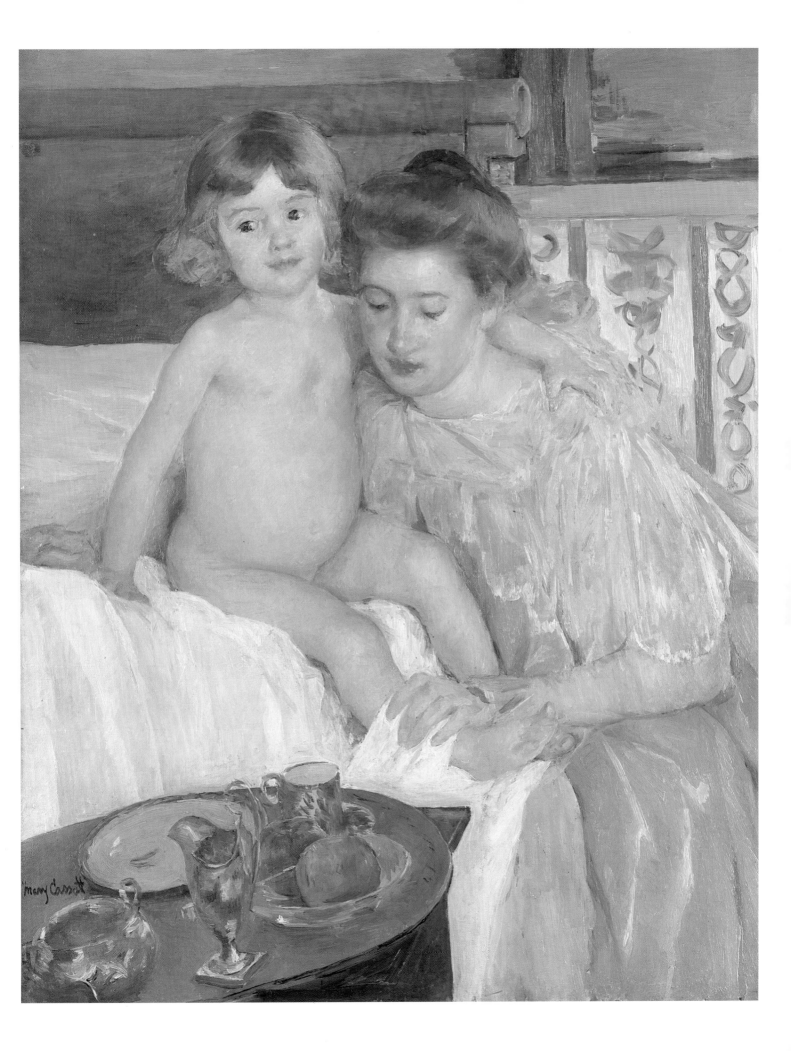

Family Group Reading

1901

TRADITION UNANIMOUSLY REFERS to the book in this picture as a "picture book." Whether the book contains pictures or print, it is clear that this incident is another of those scenes dear to Mary Cassatt in which a young girl is inducted, as it were, into some adult activity or sphere of interest by grown-up women familiar with it and convinced of its importance to the individual child and to the community to which all belong.

The blond child looks with interest at the pages and "learns" to hold the book by placing her hands over those of her mother. The seated mother also regards the pages closely, and the other woman, leaning over the back of the garden bench, seems almost puzzled by what she sees. The three faces center the composition and, with their subtle differences of expression, offer a kind of running commentary on the art of reading.

One theory of the art of Impressionism is that it sprang from the impact of Turner and Constable upon Monet and Pissarro when the two Frenchmen took refuge in London to avoid military service during the Franco-Prussian War. Here, it is worth noting the background of the painting, in which Mary Cassatt, intentionally or unintentionally, has paid homage to Constable, who could easily have painted—and did, several times—just such a slanted hillside of greensward, bounded and punctuated by trees, rising to blue sky and white cloud. The angle is different, more dramatic, in Cassatt, but the spirit of Constable lives in the scene itself.

Oil, 22 × 44"

Given by Mr. and Mrs. J. Watson Webb
The Philadelphia Museum of Art, Philadelphia, Pennsylvania

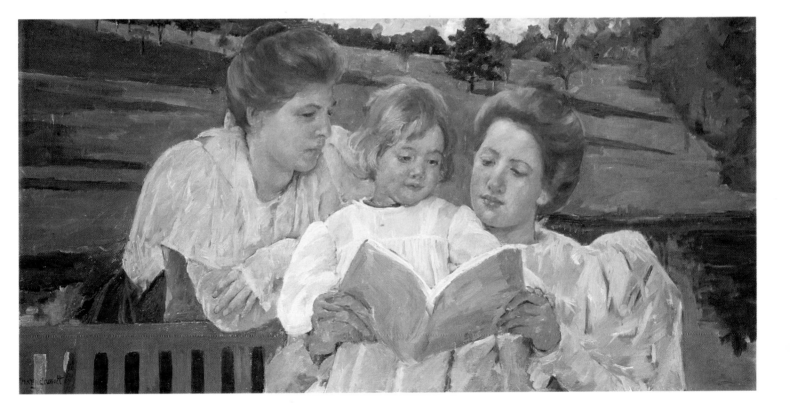

Mother and Boy

1901

THE QUALITIES in this extraordinary painting are visible at a glance, but they have been attested to by the enthusiasm of two discerning people and one discerning institution. The work was purchased from the artist by her lifelong friend, Mrs. H. O. Havemeyer, and was happily received into the Metropolitan as a distinguished feature of the Havemeyer Collection, that notable addition to the museum's holdings made in 1929. It also occasioned from Degas, Mary's mentor and artistic inspiration, high praise in a catalogue recital of her painterly virtues as manifest in the painting. Then Degas, always unable to resist a funny line with a grain of truth, concluded that the picture was indeed the quintessential Mary Cassatt, since it showed "the infant Jesus with His English Nanny."

The wisecrack, immediately reported back to Mary, caused a strain in relations between the friends that lasted some little time. Yet the grain of truth in the remark was seen by others: somewhere along the line, unrelated to Degas's *mot*, the painting acquired the soubriquet, *The Florentine Madonna*, and this title was used with sincerity and admiration, not with the little chuckle of Degas. When Florence is invoked in connection with *Mother and Boy*, we think immediately of the ceramic medallions by Della Robbia that decorate the facade of the Foundling Hospital in that city. However, if the Della Robbia family is to be mentioned, the reference should be to Luca Della Robbia's greatest achievement, the *Singing Angels* of the *Cantoria* in the Cathedral. There is, to be sure, the suggestion of a halo in the oval mirror frame behind the mother and child, but the Florentine connection is more intrinsic than that. The real point of relationship between those Della Robbia marbles and the Cassatt oil is the self-sufficiency of the child and his intense interest in what he is doing, which is, simply, looking off to the left while being held by his mother. That same independence and intensity in the task at hand is the great mark of the figures on the *Cantoria*.

Oil, 32⅛ × 25⅞"

Bequest of Mrs. H. O. Havemeyer, 1929, The H. O. Havemeyer Collection
The Metropolitan Museum of Art, New York City

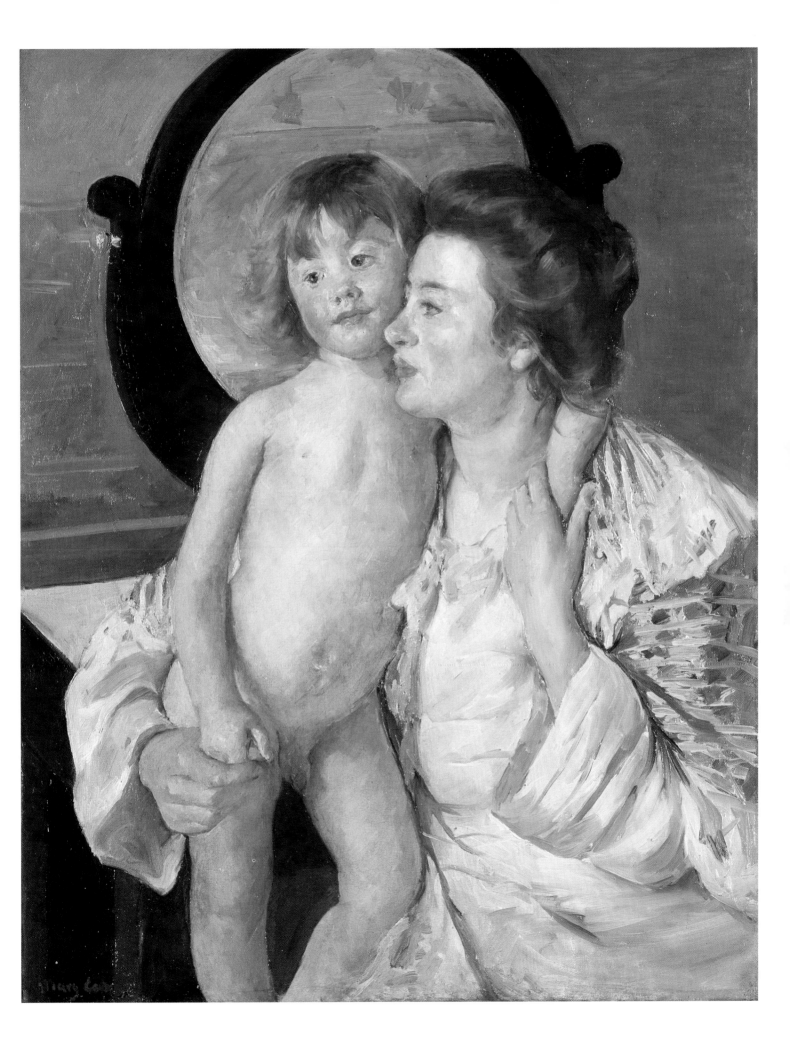

Sara in a Green Bonnet

c. 1901

SOMEHOW, THIS IS ONE OF THE MOST, perhaps *the* most, charming of all Mary Cassatt's charming pictures of children.

The sitter is Sara, a familiar and favorite child model for Cassatt in the years around the turn of the century. From having posed so often, one supposes, she is now utterly at home sitting for the artist. There is something about the costume: the white poke bonnet with its flowers and green ribbon, the rim encircling and enclosing the piquant little face, something about the neat but casually parted straight blond hair, something about the rust-colored dress with the puffed sleeves and the white lace collar, something about all of those details piled around that small, peering face, set against the green background. That something is the effect of a small person cheerfully carrying a burden rather too large for her size—although certainly not too heavy for her strength. The slightly monkeylike quality of the little face very subtly brings out all the contrast between the spirit of the child and the elaboration, the heaped up quality, of her costume. The picture works like a charm.

Oil, 16⅜ × 13½"

Gift of John Gellatly
The National Collection of Fine Arts, Washington, D. C.

Woman in a Raspberry Costume

c. 1901

THERE IS ANOTHER VERSION of this pastel, done at the same time, with the same model in the same costume but without the dog. The other picture is slightly larger and, in a way, more finished: We see more of the costume, its layered capelets, its cinchlike belt, the three big blue buttons fastening the double cape. The details of the black plumed hat are clearer and the face itself seems more sharply focused. Yet there is ample reason to prefer the Hirshhorn picture.

In the first place, this pastel contains a wonderful sense of emergence, a sense certainly enhanced by the medium itself. Because of the nature of pastel, the picture seems actually to emerge from the activity of the artist, from the surface of the gray paper into glowing, luminous color, specific form, even as you watch. Those gold and black massed marks behind the head, those grainier grays at the two shoulders, all create a sense of becoming.

This quality is also present in the face of the woman, which it is not in the more finished version. Here we definitely feel that the woman is in the process of some realization, perhaps in response to a remark of the artist, perhaps in the inner dialogue that often goes on during the process of sitting for a painting.

The dog is a definite addition. The certain similarity between the two faces, the two pairs of eyes, and the similar tilt of the nose in mistress and pet, are familiar phenomena among the keepers of domestic dogs and cats. It is sometimes thought that humans and animals, and long-married couples, grow to look a little like each other. It is more likely in this case that the resemblance was there in the first place, potentially, and was one unconscious factor in the original choice. In this picture, the faint resemblance sets up a pleasant rhythm between the faces. In that same rhythm, the white of the dog's coat is distilled, as it were, in the shimmer of silk reflections on the tie at the neck of the raspberry cape.

The only private owners of this pastel, prior to its acquisition by the Hirshhorn Collection, were the actors Charles Laughton and his wife, Elsa Lanchester.

Pastel, 29 × 23¾"

The Hirshhorn Museum and Sculpture Garden, Washington, D. C.

The Caress

1902

THIS PICTURE IS REMARKABLE on three counts. First: The three heads that provide its vital center and are placed all in a row near the top represent a total departure from the classical family group that goes back through the Renaissance to medieval painting and sculpture of the Holy Family. The traditional basic form is the pyramid, which Cassatt herself used often enough. In *Caress*, she abandons that tradition, which she had thoroughly mastered, and chooses a rare, perhaps unique, train of heads: sister, baby, mother, left to right, all in the same level, the same register. Second: The painting won for the artist not one but two prizes in exhibitions in her home country. Third: She rejected the prizes—the Lippincott at the Pennsylvania Academy and the Harris at the Art Institute of Chicago—reminding the admiring institutions that she was one of the Independents and "must stick to my principles, our principles, which were, no jury, no medals, no awards."

In spite of the unconventional composition, it is easy to see what conventional jurors saw and liked in the painting. The green dress and green chair of the mother provide a support for the whole upswelling structure of mother, baby, and sister in a series of arcs, the flesh tones of the baby surrounded by the green arm, supported by the green bodice, with the curve of mother's arm and baby's body echoed by the sister kissing the infant.

Oil, 37⅞ × 27⅜"

The National Collection of Fine Arts, Washington, D. C.

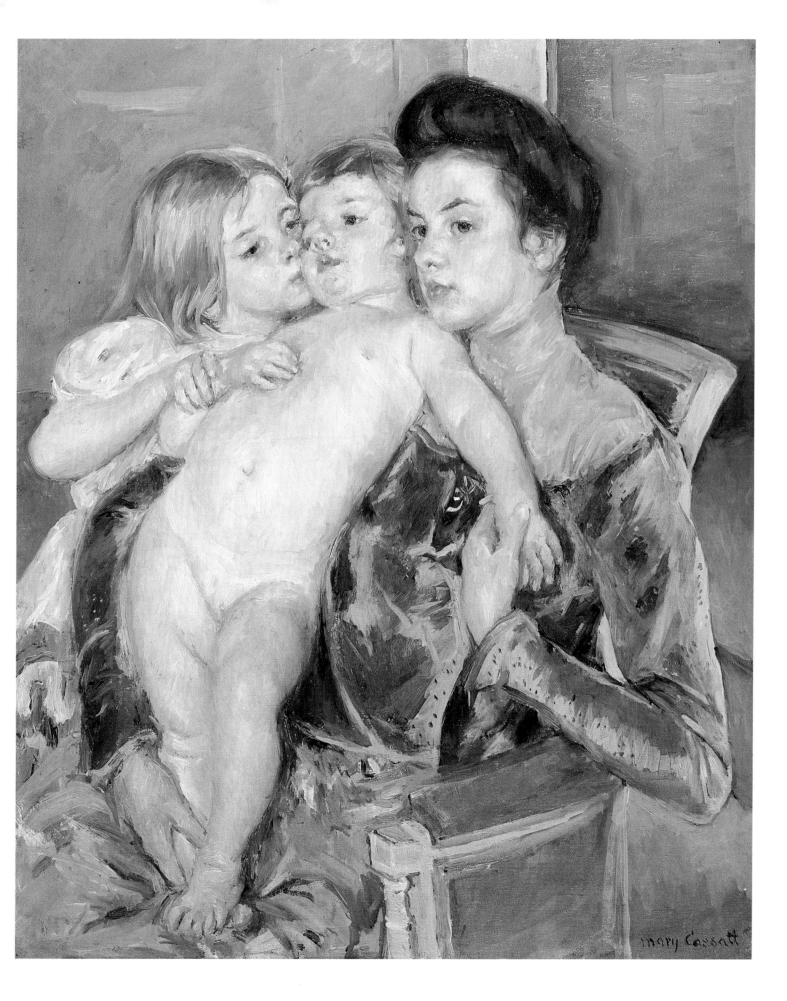

Margot Embracing Her Mother

1902

THE MAHOGANY-FRAMED SETTEE is placed diagonally across the picture and cut off by the left, right, and bottom edges, making a dramatic presentation, in center, of mother and child. The child, Margot Lux, was a girl of the neighborhood. Cassatt used her as a model several times. She was something of a beauty, one can see, and one can guess she knew it. In this and a couple of the other pictures she appears in, she is perceptibly hamming it up, being a beauty.

Her mother, on the other hand, although very good-looking, does not play it or act it, but just is. The contrast makes the picture.

Oil, 36½ × 29"

Gift of Ms. Aimee Lamb
Museum of Fine Arts, Boston, Massachusetts

128

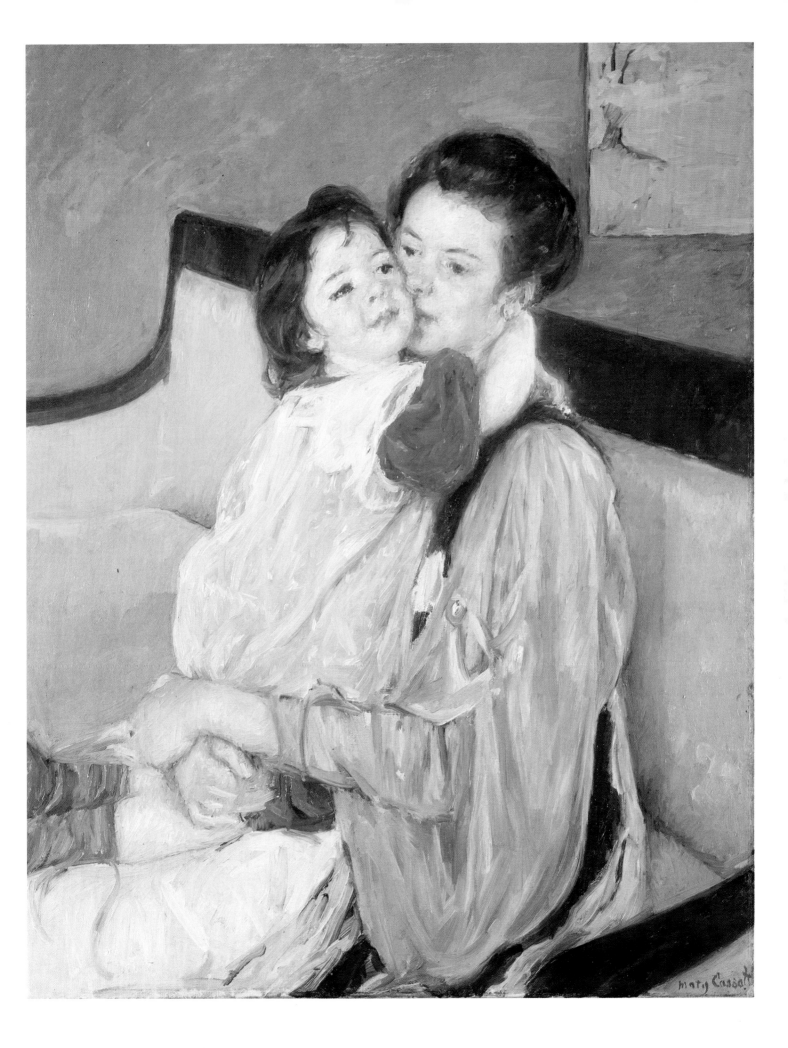

Margot in Blue

1902

THE DAZZLING EFFECT of this picture is vivid testimony to a quality of pastel that made it a favorite medium for both Mary Cassatt and Degas. This is the quality: that of all the media used to apply color to a surface, pastel is the least mediumistic. In pastel, the artist is dealing as closely as is possible with pure color. In the sticks of color that the artist in pastels uses, there is a binder, of course: in Cassatt's day it was usually gum tragacanth; nowadays it is methylcellulose or other laboratory products. But the effect of the binder on the stroke of color on paper is next to nothing. It *is* nothing when compared to the effects of oil, for example, or egg yolk or wax or water. Hence this beautiful blue.

Cassatt achieved the dazzle in two ways: she applied the blue in short, sharp strokes, scribbling it here and there, and then she added white lightening with a dazzle of its own on top of the blue. Likewise, the purer white of that elaborate hat and tied veil is touched in places with blue.

Margot was a child of the neighborhood where Cassatt was living at this time. Cassatt's practice with such amateur child models was to use them again and again, so that they got used to her and to the process of sitting there while the lady made her marks upon the paper. There are more than two dozen pictures of Margot in one costume or another, alone or with her mother. Thus she sits here in blue with a self-possession rare in one so young.

Pastel, 24 × 19⅝"

The Walters Art Gallery, Baltimore, Maryland

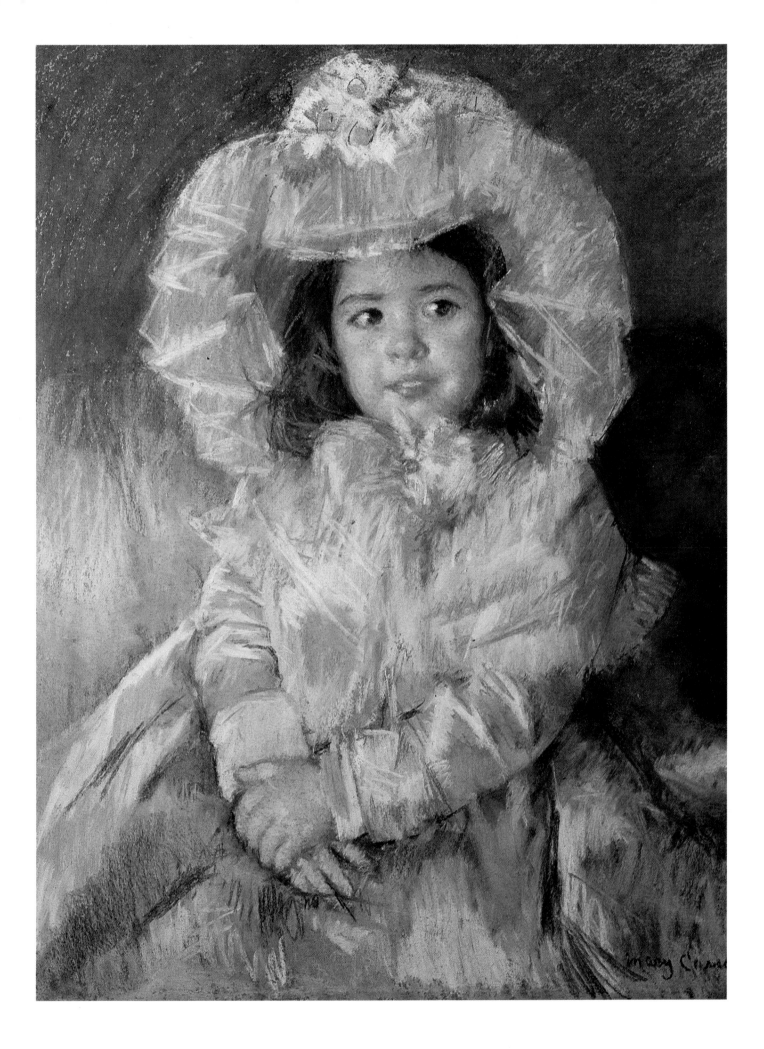

Reine Lefebvre Holding a Nude Baby

1902

THERE IS A STUDY for this painting and a whole small series of related pastels, sketches, drawings, in which Reine Lefebvre and her baby gradually, as it were, come into focus. This picture is the climax and resolution of the entire group of works, the goal toward which they all converged.

The young mother crosses her arms to make a doubly secure seat for the baby and to clutch the lower legs tightly, while the baby locks arms around the mother's neck. Reine's orange robe, with lighter tufts like three-dimensional polka dots scattered on it, is cuffed and collared in brown fur, which somehow adds to the general feeling of maternal warmth: black or white fur would not have been right.

As always, there is no hint of cloying sentimentality between the two. Reine looks perhaps a little tired, which is the way mothers of young children tend to look, much more frequently than they look loving, glowing or melting. The baby has a rather grand supercilious ness in its glance. It also has the fat tummy that infants take so long to outgrow. All in all, this picture shows the quintessence of the Mary Cassatt mother-and-child: no hype, no nonsense, no sentiments that ought to be there but are not, just what the penetrating eye sees, the talented hand reveals.

Oil, 26¹³⁄₁₆ × 22½"

Worcester Art Museum, Worcester, Massachusetts

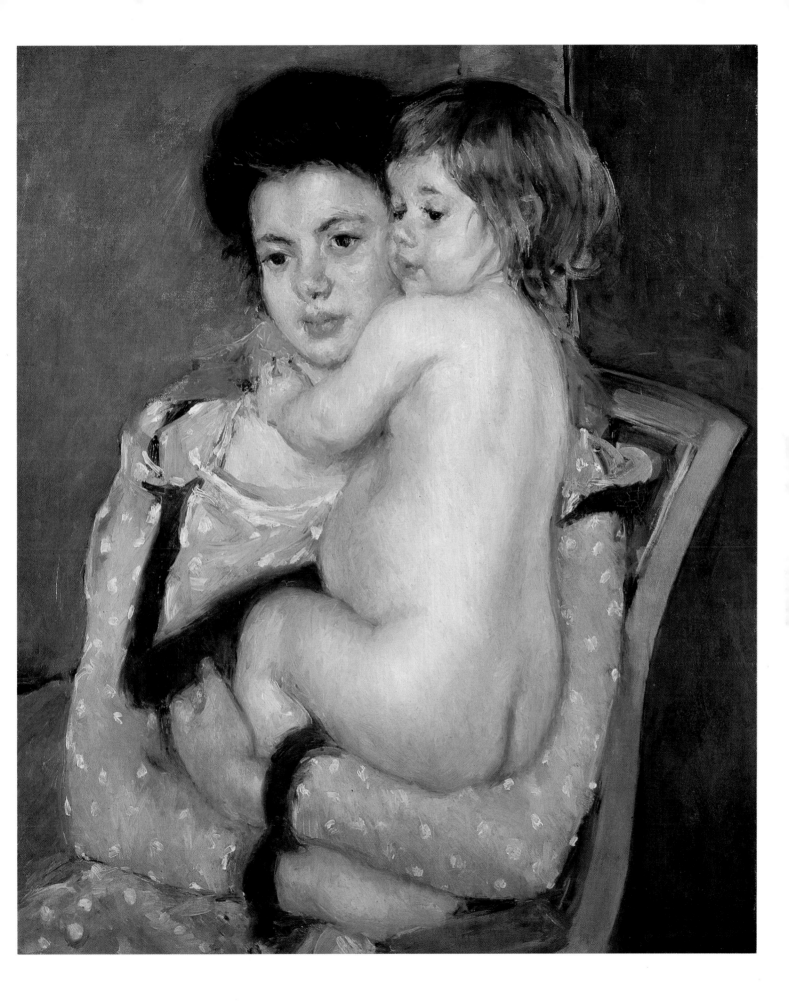

Young Mother Sewing

1902

THIS IS A BEAUTIFUL PICTURE: mother working, ignoring the painter, child leaning on mother's knee, staring right into the precamera camera, and, that rarest of things with Mary Cassatt, a smidgeon of landscape seen through the expansive windows. The strong black and white stripes of the woman's dress are muted by her blue apron, which serves as a transition to the white dress of the child. Cassatt creates here the basic pyramid out of two figures, although in classic, that is to say Renaissance, paintings on the theme, the pyramid takes three figures, sometimes four.

Beyond that, though, the painting is of special interest because it gives us an insight into how Cassatt worked. There exist, in private collections, first, a "sketch" and, second, a "study" for this painting. The sketch is sketchy: the figures are blocked in much as they appear in the finished painting, except that we, the viewers, are backed significantly farther away from the figure group. We see, for example, the little girl's black-stockinged legs and shoes. The mother's skirts are indicated only by outlining lines.

The "study" is in pastel. The little girl looks just off the viewer's sight line and the landscape is much more sketchy than in either the "sketch" or the finished painting. The girl's hands are completely hidden in her bodice and the mother's skirts.

In the painting, as we see, the hands are back out again, one finger in the mouth, the others plunked into the cheek, the left hand clasping the right elbow. Also, the orange flowers in the blue and white vase make their appearance for the first time. The mother remains much as she has been except for the addition of the straying lock of hair over her left temple.

Oil, 36¾ × 29"

Bequest of Mrs. H. O. Havemeyer, 1919, The H. O. Havemeyer Collection
The Metropolitan Museum of Art, New York City

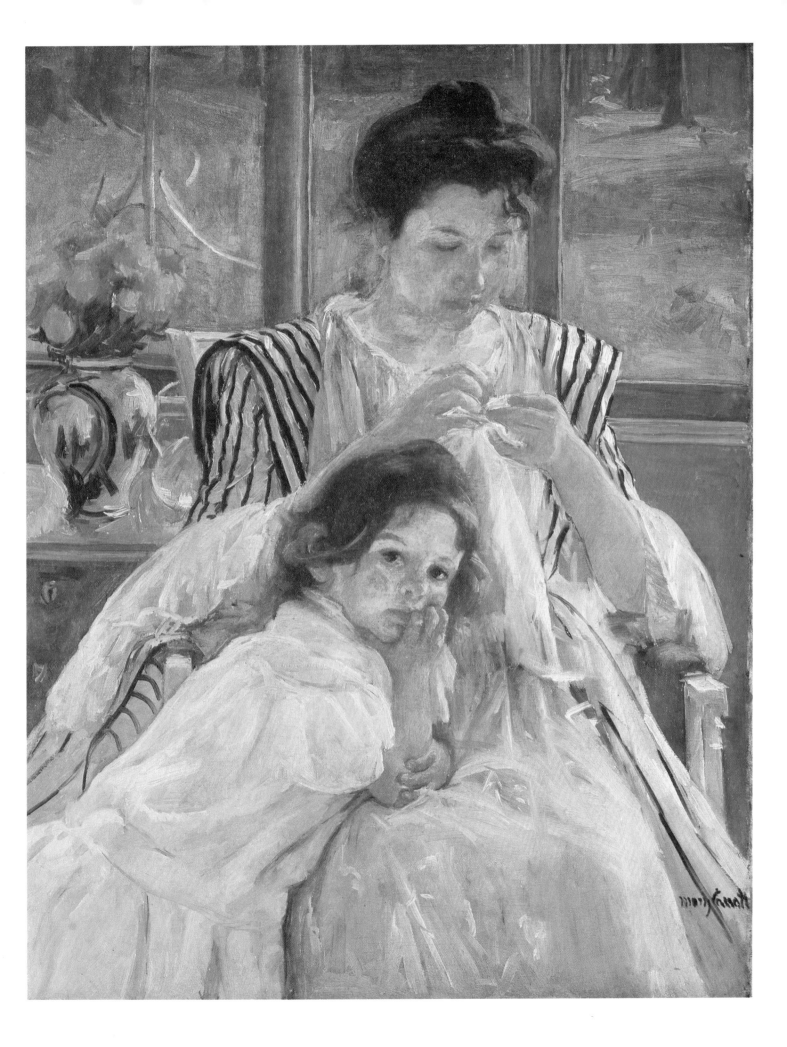

Simone and Her Mother in a Garden

1904

THE CHILD'S PINK FACE might have blended into the bright pink dress, the straw of the hat, but the dramatic black velvet ribbon around the rim of the hat, with its great black bow just above the modest pink one in the child's hair, makes that impossible, isolates, and emphasizes the head. The effect is equivalent to the halo in early Renaissance paintings, but this face is not that of saint or angel. Instead it is the face of a real, truly perceived little girl, piquant, inquisitive, at ease and happy with herself, her mother, and the garden.

Her mother, too, serves almost as a frame for Simone's young freshness. Seen only in a back three-quarter view, the mother exists chiefly to hold Simone, chat with her, attend to her. The white dress is less vivid than the girl's pink, and it is supported by the more colorful blue of the slatted garden bench.

The garden itself raises a familiar question about Cassatt. The Impressionists' group, of which she was a loyal, if occasionally cranky, member, is remembered for opening up the whole glowing out-of-doors to the artist's view. Out from the studio, into the parks and forests of Paris and its environs, up or down the river, north to the beaches, south to the sun: that was the itinerary for painters from Monet and Pissarro to Van Gogh and Gauguin, with Gauguin going half way around the world. But Mary Cassatt stayed home and painted what she found there, using friends, family, servants, and their children as models. Like T. S. Eliot, she knew and could portray the drama in "the taking of a tea."

Grateful as we must be for that, we nevertheless see clearly what we missed when Mary Cassatt settled into staying indoors. Outdoors for her was a private garden and never a public one, let alone the wild woods. Just this little snatch of flowering bushes and borders in the background reminds us that she could see, and help us see, the beauties of nature as well as any of the Impressionists could.

Oil, 24⅜ × 32⅝"

The Detroit Institute of Arts, Detroit, Michigan

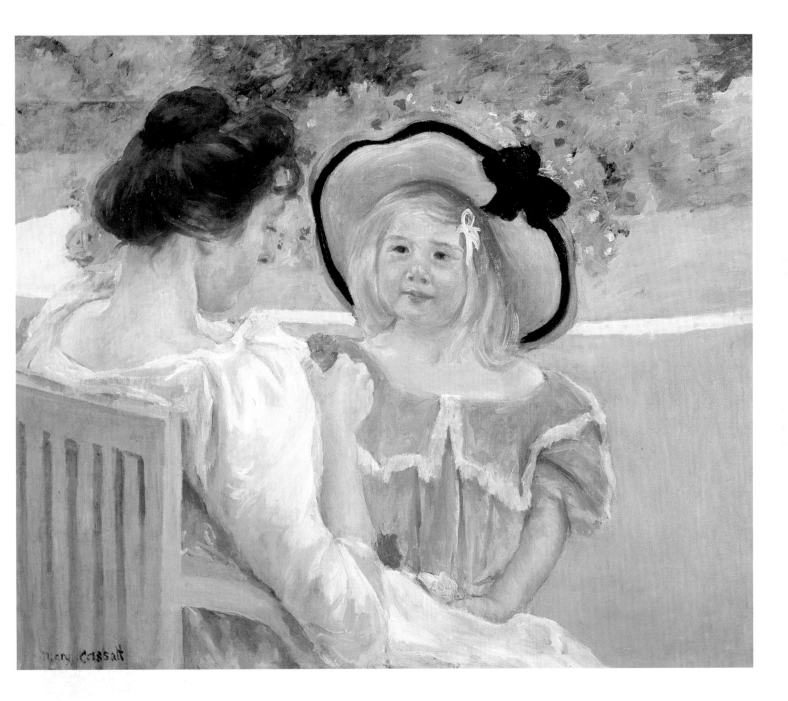

Mother Wearing a Sunflower
on Her Dress

c. 1905

MIRRORS FASCINATED MARY CASSATT, as they have many an artist. She used them, for the most part unobtrusively, in her opera pictures and regularly in her nursery or boudoir pictures of mothers and children. Here, as in a few other pictures, Cassatt used two mirrors and the effect is fascinating. A simple double portrait is transformed into a group picture; a total of five images appears from the two people who actually sat for the painting. The reflection in the large wall-mirror is background, an echo of the central figure composition. The center of everything is the indeterminate point at which the gaze of the mother, the gaze of the child, and the gaze of the child's reflected face in the small, handheld mirror converge.

The sunflower is an unusual motif, and it spreads its golden summer light throughout the painting, played against green, the other color of growth. The greens in the painting are straight lines, hard and firm, solid wood. The yellows are soft—the great hanging sleeve of the gown, the sunflower itself, the body of the gown with its shimmer of white lines of reflected light—even the hard metal of the hand mirror's gold frame is a circle, not a line.

The two golden figures themselves embody that soft rotundity of the yellows: the girl's torso and legs, the woman's shoulders, bosom, ample cheeks, and piled-up coiffure.

As in nature, there are already signs of inevitable decay amid the fecundity. The joining of the arms at the handle of the mirror is true, strong Cassatt composition, but the rendering of those hands is unfortunate. Twenty years earlier, even three or four years earlier, the fingers would have been sharply delineated, differentiated. Here they get a little mushy, a portent, perhaps, of the cataracts that would, in a few years, end Cassatt's painting altogether.

Oil 36¼ × 29"

Chester Dale Collection
The National Gallery of Art, Washington, D. C.

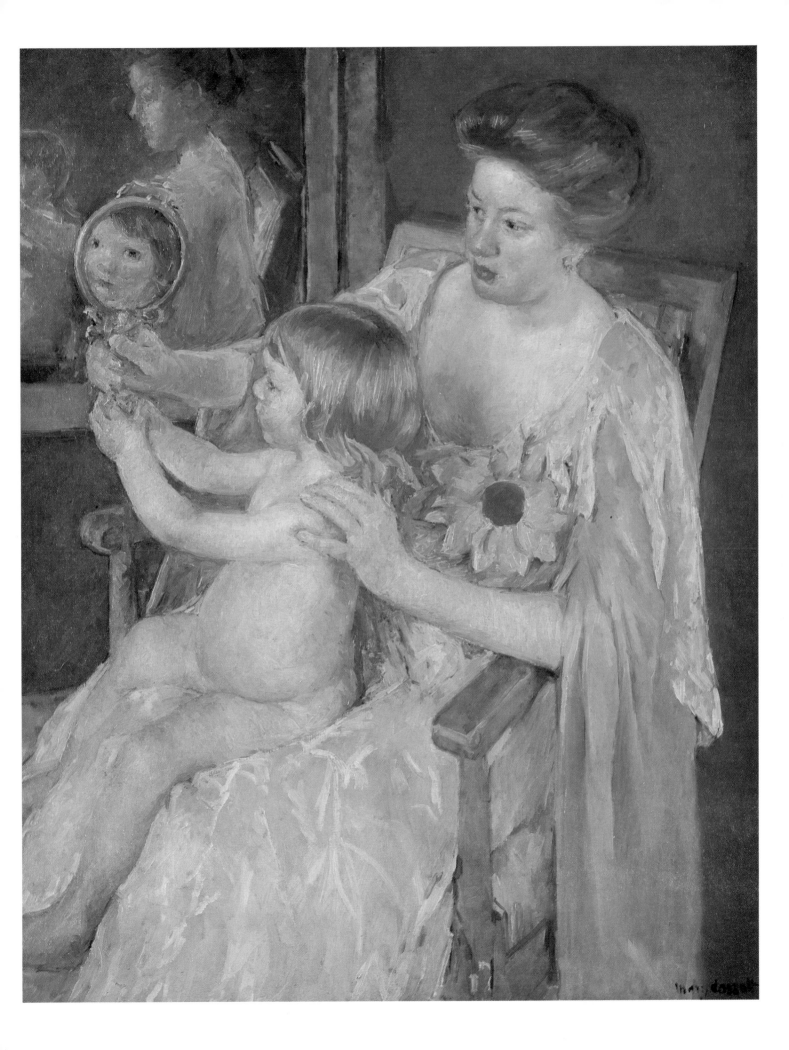

Woman and Child Admiring a Baby

1906

A DEFINITE MAJOR VARIATION on Cassatt's major theme of mothers and children is shown here: mother and baby with older child in attendance. Since the older child is almost always a girl, hence woman-to-be and potential mother, this variation on the theme can be interpreted as a rite of introduction to maternity. Indeed the French title of this painting is *Maternité*. For a modern child, the arrival of a baby in the family has the charm of playing with dolls, only much more so: the doll now is alive, moving, feeding, responding. On a deeper level, nothing less than the continuation of the human race is being assured, a new generation is introduced, gently and charmingly, to the mysteries of generation itself.

Whether such recognition of ancient human ritual was intended, consciously or unconsciously, by Mary Cassatt in painting this and similar pictures, there is no doubt at all that she intended to use the strictly pictorial advantages of three people over two. As an early and constant student of the Old Masters, Cassatt was well aware of the advantages of the triangular structure in so many religous paintings of the High Renaissance: the Virgin, Child, and St. John; the Virgin, Child, and St. Anne; The Virgin, Child, and St. Joseph. The variations were endless; the effect was always an increase in pictorial dynamics; and so it is here.

There is, in the first place, the traditional triangle on the picture plane formed by the three heads, blond Sara leaning her head on mother's shoulder, and both of them rapt in admiration of the baby, who, for its part, stares past them. But Cassatt has created another triangle in depth behind that of the picture plane. If you add the potted plant in the corner, as the painter did, the result is a triangle in recession as well as the surface triangle in plane, the deeper triangle backed up by the receding planes of the two walls, the one on the left explicit, the one on the right implied.

Cézanne remarked that he wished to make of Impressionism an art of the museums, by which he meant an art with a "hard" structure beneath the "soft" shimmer of light effects that was the constant temptation, as well as the glory, of the Impressionist painters. Surely here, Mary Cassatt, in her own way, attained Cézanne's goal, and she did so in many other paintings too.

Oil, 29½ × 36¼"

Gift of Dr. Ernest G. Stillman
The Fogg Art Museum, Harvard University, Cambridge, Massachusetts

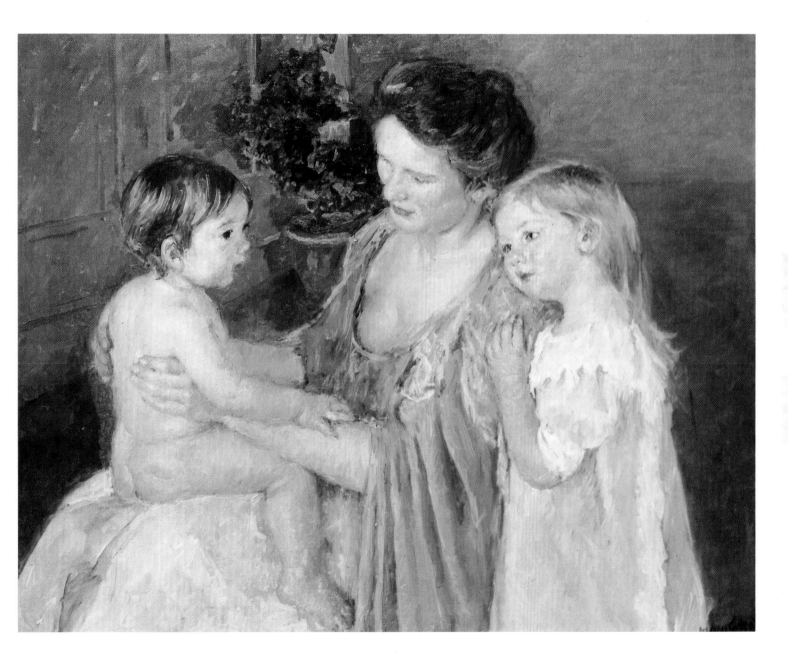

Girl in Green

1908

THIS PICTURE HAS A SPECIAL INTEREST because, as is very rare in Mary Cassatt's paintings of one or two people, the background is opened up. We see into the next room, noting the rug on the floor, the chair at the doorway, the fireplace on the farther wall. Françoise is, in short, "placed" in a continuing flow of space as Cassatt sitters more typically are not. Usually they are placed very close and somewhat off-center to a background wall, with a mirror framing their heads, perhaps, or some feature of interior architecture weighting the whole composition one way or the other.

Here that predeliction for the off-center composition is carried in the near background. Françoise's face and figure are centered, but the chair in which she sits is turned away from parallelism with the picture plane and clearly moved toward the left. The sitter retains her central position in the picture only by having moved forward on the chair and to its right: thus we see the entire left arm of the chair, almost nothing of the right one, obscured by the girl's dress. Similarly, a diagonal into the distance is set up between the fireplace in the far background and the back and arm of the chair visible "downstage." Meanwhile, Françoise devotes total concentration to her needlework, her small creation taking place above a veritable outpouring of such work in the elaborate pleats and layers of her soft green skirt.

Oil, 32 × 25½"

Gift of Dr. Ernest G. Stillman
The City Art Museum of St. Louis, St. Louis, Missouri

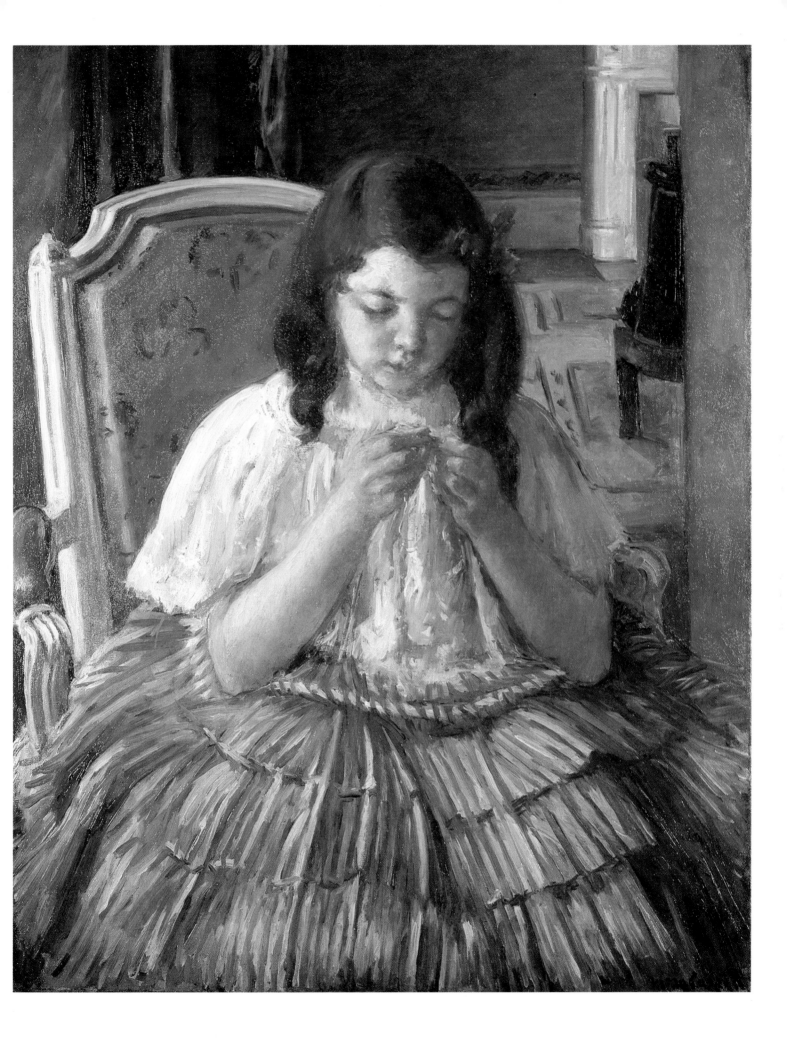

Mother and Child

1908

THE ARCHITECTURAL BACKGROUND, with its suggestion of Renaissance pictures, is unusually strong here: Mother and child are framed by the panels of the wall which also enclose the console surmounted by the round mirror, both in dark mahogany that contrasts with the mother's pale yellow-green gown, the child's nude flesh and, of course, the rose scarf itself, winding around both figures. The severity and gravity of the framing elements in the background, contrasting with the gossamer fabrics and the child's rosy flesh, are echoed in the very heart of the figure group, in the deep look of mutual regard exchanged by mother and child. There, too, gravity is the keynote.

The powerful pyramid of the figure group, also Renaissance in suggestion, is softened and to some extent dissipated by the extreme fragility of the fabrics. In those Florentine pictures of madonnas and children, there were never any floating veils of gossamer or silk: mantle, gown, and apron were all weighted cloth, opaque and heavy.

Although she was to live another eighteen years, this year marked Mary Cassatt's last visit to America. Now sixty-four, she visited her brother Gardner in Philadelphia. It was an extended visit and she was there for Christmas following her one-woman show in Paris the month before.

Oil, 45 × 34½"

Bequest of Miss Adelaide Milton De Groot, 1967
The Metropolitan Museum of Art, New York City

144

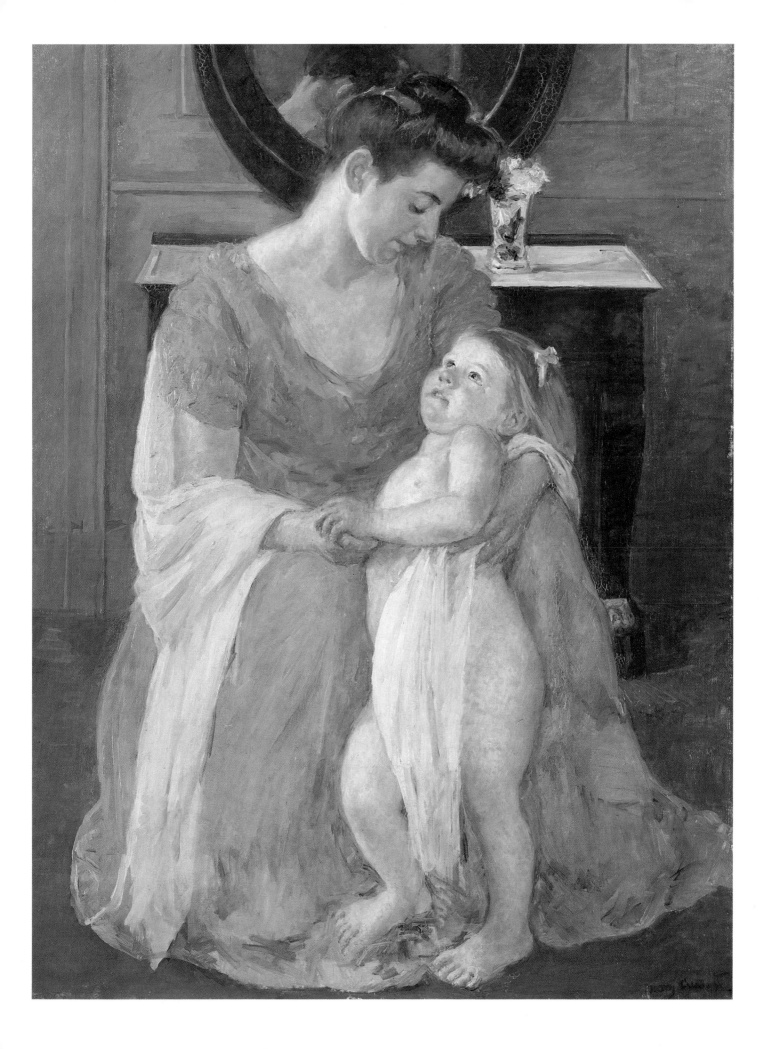

Mother and Child in a Boat

1908

THERE ARE NO FEWER than seven oil sketches and two studies in pastel for this painting. Yet only the finished, full-dress work was exhibited in Cassatt's one-woman show in Paris the year of this painting. That says something about the artist's attitude toward her work: for her the product was the point, not the process. The same attitude is present in an anecdote Jean Renoir related about his father. As the maid started to light the evening fire, she took up the evening paper as a starter. Renoir seized it from her, saying, "No, no, I haven't read it yet; here, use these," and gave her instead a handful of sketches. For Cassatt as for Renoir, the preparatory sketches and studies had served their purpose when the main work was completed. The earlier works were suitable as gifts to friends, or, more often, gifts to her longtime, faithful housekeeper, Mathilde, whose "Mathilde X" sale in Paris shortly after the artist's death is widely accepted as the beginning of the international trade in Cassatt's works.

Against the summery green of the foliage, reflected in the water and all very subtly painted, mother and child, in nicely contrasting color schemes, sit in the floating craft. The mother holds the girl's left hand in her own as the child dips or drags her feet in the water. In a typical Cassatt perception, the girl concentrates to the point of absorption on her own pleasurable feelings in the afternoon, the water, the drift. By contrast, the mother shows just a trace of incipient anxiety, or alert care, at least, about the risks—minimal, to be sure—in the situation, and she watches the girl rather than the day.

Oil, 45½ × 31¾"

The Addison Gallery of American Art, Andover, Massachusetts

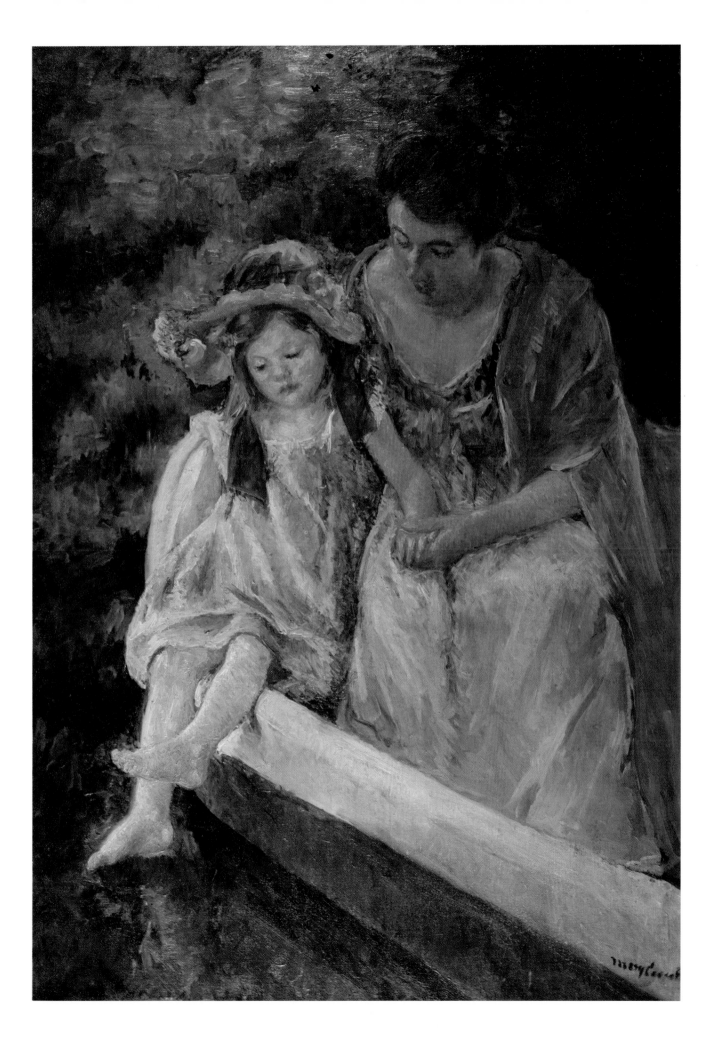

Mother Nursing Her Baby

c. 1908

THE ACT OF NURSING, breast-feeding, is the most intimate connection between mother and child after birth has taken place, and it has automatic symbolic meaning in that relationship. So it is surprising that Mary Cassatt, devoted to mothers and children and relationships between them on all levels, did not paint this quintessential moment of motherhood and babyhood more often than she did. Among the hundreds of oils, pastels, drawings, and prints that Cassatt created on the general theme of mother and child, perhaps six, certainly not more than ten, depict the act of nursing. Why?

It was surely not the absence of models. Given the general state of maternal knowledge in the decades before and immediately after the turn of the century, it is fair to assume that every mother Mary Cassatt painted holding her baby also nursed that baby at some time or other. Nor would there have been any false modesty. There was no bottle-feeding to speak of. Some mothers were unable to nurse their babies, others wished not to do so; both such put their babies out to "wet-nurses," a group now unknown, who would accept other people's babies to nurse along with their own. But this practice was almost unknown among the country folk who served as models for these paintings.

Possibly Cassatt's heightened reverence for the motherhood she never experienced is behind this strange reticence or reluctance to deal extensively or frequently with this essential aspect of the motherhood she celebrated so often in her work.

Toward the end of her life, Cassatt often remarked that a woman's principal purpose in life was to bear and raise children and she, of course, had done neither. She came close to dismissing her work as not really important, after all, compared to what she had not achieved, namely, first, to be beautiful (she really thought that), then to attract a suitable husband and be married, and finally, to bring forth the children for whose sake nature had made her a woman in the first place.

This view is remarkably at odds with Mary Cassatt's long and dedicated involvement with the cause of women's suffrage, or what was more generally called Female Emancipation. Partly it can be explained by the descent of an angry melancholy as she found herself in old age, with one after another friend or family member dying and leaving her without descendants of her own.

The picture is a fine, solid pyramid in structure, topped off by the potted plant on the taboret behind the mother, and with a lovely interchange of interest between mother and child.

Oil, 39⅝ × 32⅛"

Gift of Alexander Stewart
The Art Institute of Chicago, Chicago, Illinois

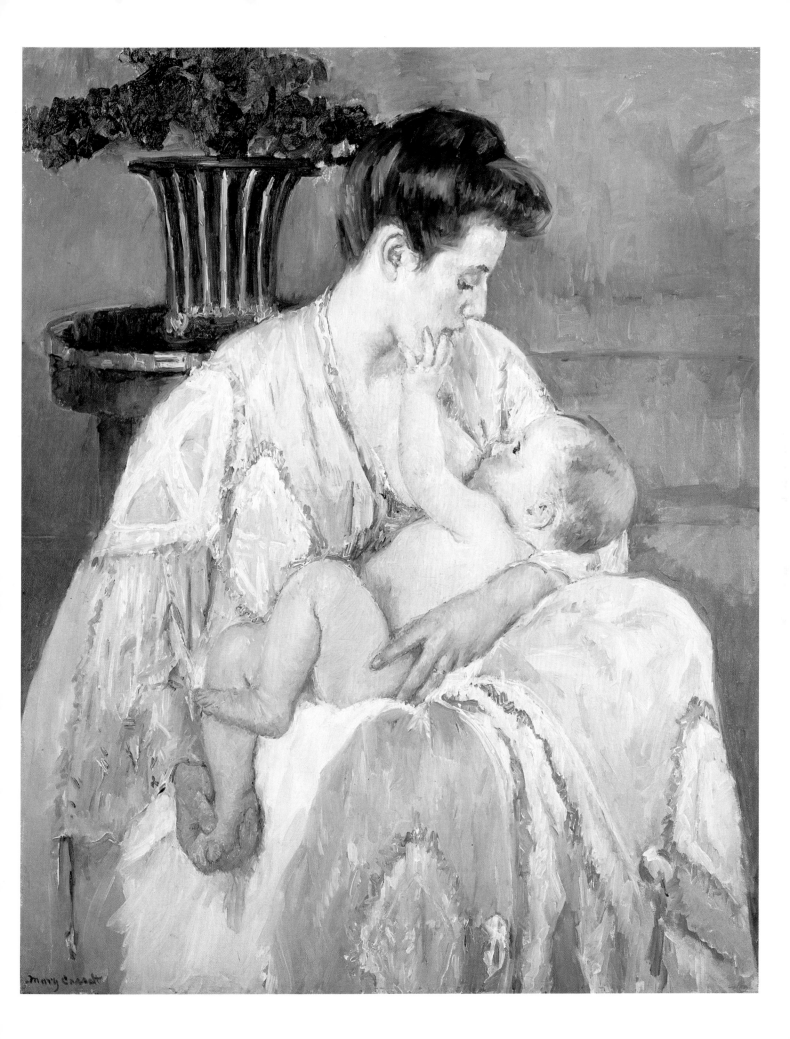

Young Mother and Two Children

1908

THIS IS AN EXTRAORDINARILY appropriate picture for a house which is not only the major center of political power in this country, but which is usually a family residence as well, and hence, almost regardless of the wishes of the occupants at any given time, one of the great symbolic centers of family life in America.

In the naturally aristocratic mien of "Mother Jeanne" there is a suggestion of the exemplary Roman matron who presented her children to her company with the statement, "These are my jewels," an echo of the classical past that relates to the quite conscious classicism of the beginnings of the American Republic and of its principal buildings in Washington, including the White House.

The pyramidal structure of the mother and her children—they are almost subsumed into her form—brings to mind those no less classical pyramids of mothers and children in Renaissance painting. Here, however, there is no conventionally depicted actual or incipient divinity, whether in haloes or in looks of pious detachment. On the contrary, these are three very real people: "Mother Jeanne" holds both her children with loving attention, looking down at the baby; the little girl leans against her mother and looks across at the baby with no hint of sentimentality, while the baby looks at nothing in particular, quietly happy to be held and cared for.

The splendid, sturdy pyramid of the arrangement would be only that, if posed solely against the neutral background of the wall of the room. However, Cassatt, as was her way, opened that wall with a window off to the right of the picture, giving the subject air and light and breaking the formality of the Renaissance design.

There are almost a dozen studies for this picture, in pastel, oil, and watercolor, unfortunately scattered across Europe and America in public and private collections. Together, they offer a rare insight into Cassatt's working methods. Detail after detail is painted again and again until it seems right, and then the whole is assembled into the fine work we have in our First Family's home.

Oil, 36¼ × 28"

The White House, Washington, D. C.

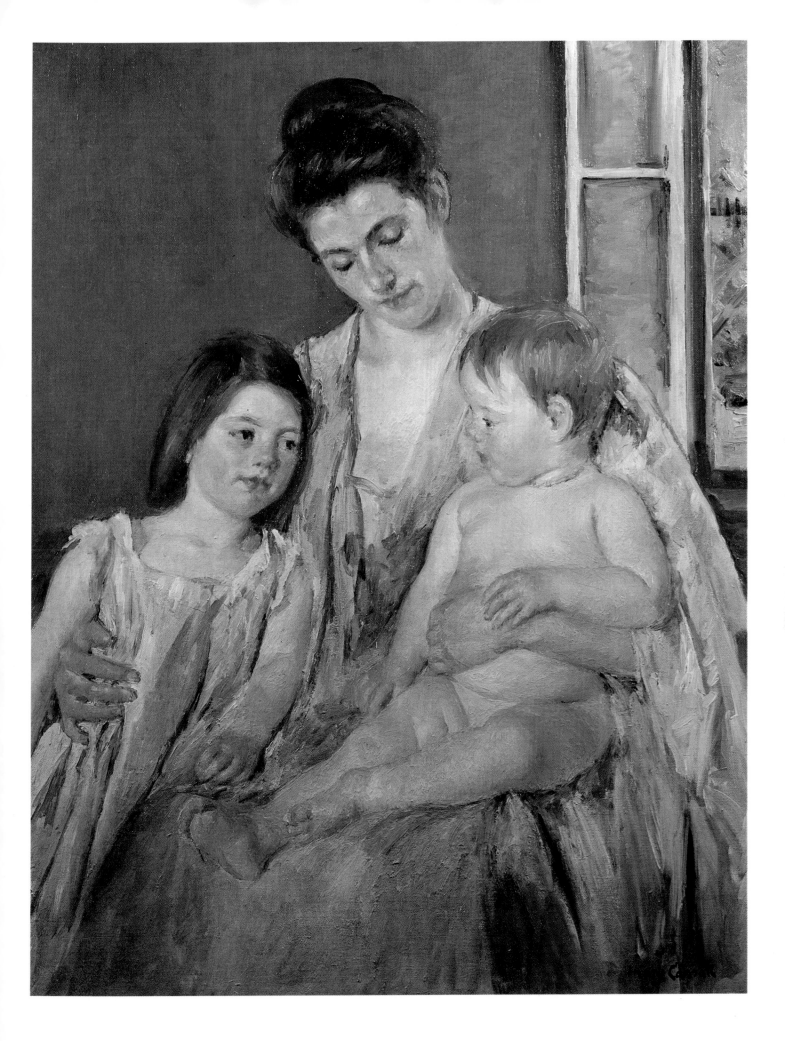

Young Woman in Green, Outdoors in the Sun

c. 1909

A SENSITIVE PAINTER usually marks the changes of fashion in his work. This young woman is decidedly more casual, less formal or formidable in attire and general demeanor than any of the women Mary Cassatt painted from twenty to thirty years earlier, her first notable period of achievement. This subject, in the way she is dressed, the way she looks and, most importantly, the way the artist looks at her, recalls later women in paintings by Glackens or Sloan or even, later still, Isabel Bishop, all of them Americans.

The casualness of the subject is perfectly fitted for the freedom of the painting itself. Framed by her large, trimmed hat and the white ruffle below her throat, the subject stares openly off to the right. To the left, the glass doors suggest those on a verandah opening into the house. Behind the sitter, the loosely brushed-in foliage reflects the light and shadow of a summer day.

The light and shadow on the face of the sitter are also pure Cassatt, showing her extraordinary sensitivity to tiny touches of light, such as that on the woman's left eyebrow and nose and just above her lips.

Oil, 21¹¹/₁₆ × 18¼"

Gift of Dr. Ernest G. Stillman
The Worcester Art Museum, Worcester, Massachusetts

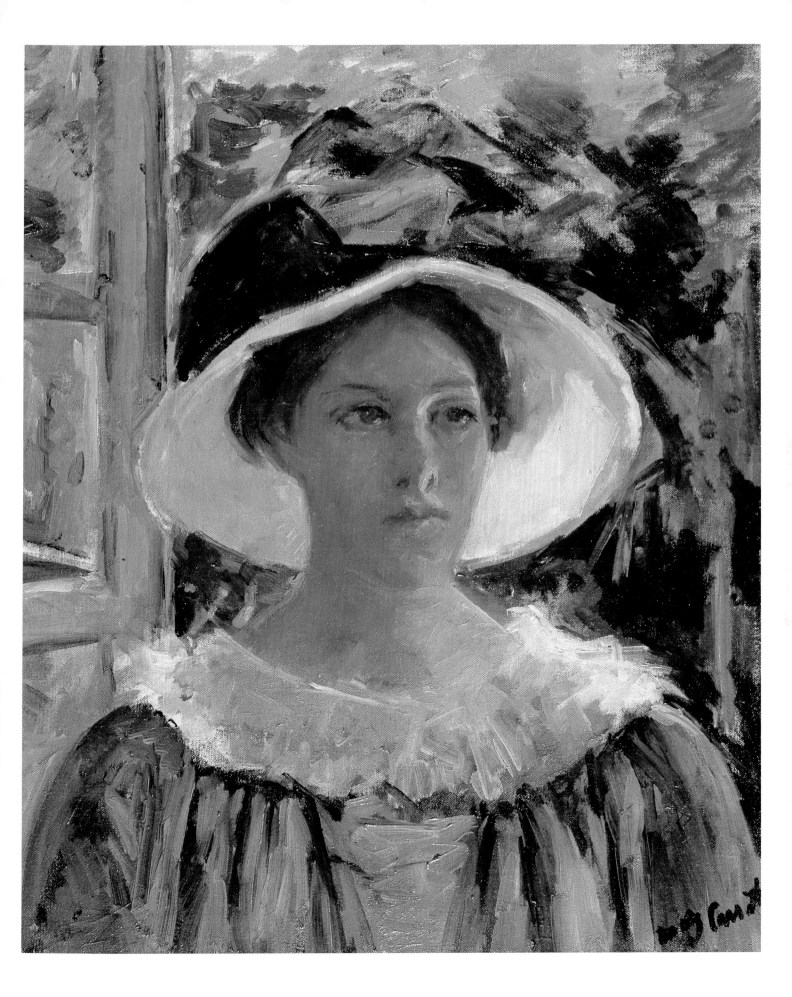

Mother, Young Daughter, and Son

1913

FOLLOWING THE DEATH of her brother in 1911, Mary Cassatt suffered a complete breakdown and did no work at all for two years. In 1914, her vision, which had been failing because of cataracts for several years, collapsed altogether. She never painted again and lived the last dozen years of her life in blindness. Nevertheless, she managed to navigate around her familiar rooms and yards and to receive visitors. This pastel, one of the largest she ever created, is from those brief months between recovery from breakdown and the onset of blindness.

This major work places Cassatt in the central tradition of artists who sharpen their skills and perceptions throughout their lives, artists who, at the end of their production, are working better than ever, often exploring new areas, new techniques, new refinements.

Here Mary Cassatt addressed a familiar theme, and she was using a familiar medium, one she had long made her own. But the old smoothness, which, from Degas, she had learned to impose upon pastel, is missing. Almost the entire surface is composed of scribbling, swiftly applied strokes of color. The modeling of the figures is no less sure for the absence of that painterly method. On the contrary, the treatment of the infant's body—the chest, the jaw, even the indentation for the navel—is a miracle of sure modeling, as is the treatment of the mother's upper chest.

As if in a hurry to get the picture down before the fading of the light, Cassatt seems to have created the surfaces in a flash—like lightning revealing a landscape—yet everything is correct and convincing in the shower of colored strokes.

Pastel, 43 × 33½"

Marion Stratton Gould Fund
Rochester Memorial Art Gallery, Rochester, New York

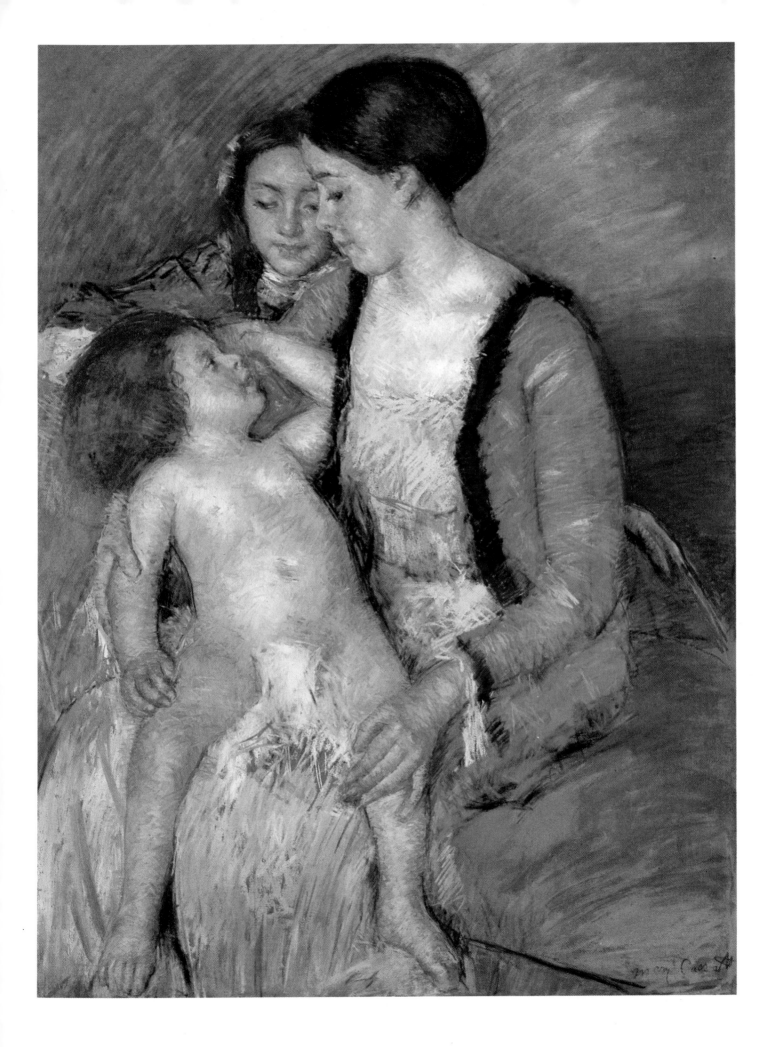

Selected Bibliography

Breeskin, Adelyn Dohme. *The Graphic Work of Mary Cassatt, a Catalogue Raisonné.* New York, 1948.

———— *Mary Cassatt: A Catalogue Raisonné of the Oils, Pastels, Watercolors, and Drawings.* Washington, D.C. 1970.

Bullard, E. John. *Mary Cassatt. Oils and Pastels,* New York, 1972.

Carson, Julia M. H. *Mary Cassatt.* New York, 1966.

Cassatt, Mary. Correspondence addressed to Mrs. H. O. Havemeyer, 1900 to 1920. Typescripts of original letters. National Gallery of Art, Washington, D.C.

Graphic Art of Mary Cassatt. Exhibition catalog, introduction by Adelyn D. Breeskin. The Museum of Graphic Art, New York, 1967.

Havemeyer, Louisine W. "The Cassatt Exhibition," *The Pennsylvania Museum Bulletin,* XXII, 113 (May 1927), pp. 373-382.

Kelder, Diane. *Great Masters of French Impressionism.* New York, 1978.

Mary Cassatt 1844-1926. Exhibition catalog, introduction by Adelyn D. Breeskin. National Gallery of Art, Washington, D.C., 1970.

Rewald, John. *The History of Impressionism.* Revised and enlarged edition. New York, 1961.

Sargent, Whistler and Mary Cassatt. Exhibition catalog, introduction by Frederick A. Sweet. The Art Institute of Chicago, 1954.

Ségard, Achille. *Mary Cassatt: Un Peintre des Enfants et des Mères.* Paris, 1913.

Sweet, Frederick A. *Miss Mary Cassatt: Impressionist from Pennsylvania.* Norman, Oklahoma, 1966.

Watson, Forbes. *Mary Cassatt.* New York, 1932.